RACHEL LACHOWICZ

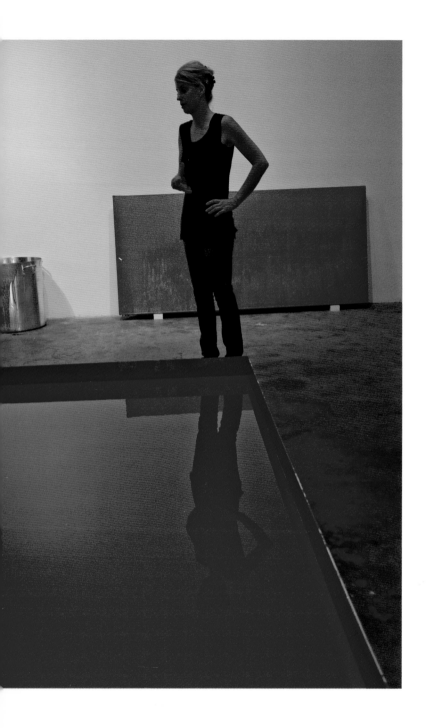

RACHEL LACHOWICZ

Essays by

GEORGE MELROD

AMELIA JONES

JILLIAN HERNANDEZ

Shoshana Wayne Gallery

Santa Monica, CA

Marquand Books

Seattle, WA

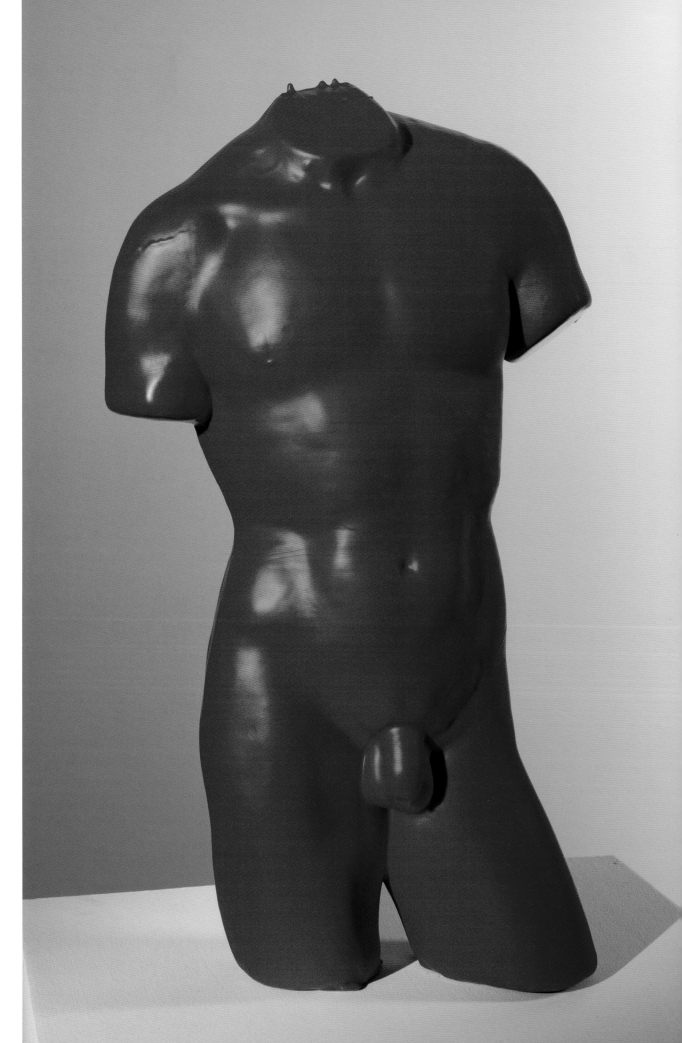

RED DAVID, 1991
LIPSTICK, PLASTER
23 X 13 X 7 INCHES
PRIVATE COLLECTION, NEW YORK

CONTENTS

by GEORGE MELROD

RACHEL LACHOWICZ:
THE MAKEUP ARTIST

"I feel that my works are feminine and delicate; it may look strong, but it is delicate. True strength is delicate."
~ Louise Nevelson

"The best way to beat discrimination in art is by art. Excellence has no sex."
~ Eva Hesse

WITHOUT KNOWING RACHEL LACHOWICZ, one might think of her as a rebel in high heels, lobbing her elegant feminist retorts to the art world in a cocktail dress, with a copy of *The Beauty Myth* in hand. But the impression, which derives partly from Lachowicz's famous/infamous 1992 performance in which she reinterpreted Yves Klein's *Anthropométries,* is a somewhat misleading one. Although she makes a wily provocateur, she is first and foremost a conceptual sculptor—and a very agile one at that, applying the rhetoric of appropriation and conceptual art to a practice as a committed fabricator of highly tactile objects. In the studio, she can be a laborer, adept at tailoring various machinery and materials to her will; in its hands-on nature, her technique has far more in common with those of the modern-

PORTRAIT OF A FEMINIST, 1993
ENAMEL ON GLASS
2 ELEMENTS: 28½ X 47¼ X
2½ INCHES EACH

ist male artists she critiques. As an appropriation artist, using art history as her wellspring, she examines not just canonical forms and icons from the discipline, but also its divergent processes and conceptual strategies, filtering them through her own interpretative lens to create uncanny objects that are at once interstitial yet autonomous. While Lachowicz's reputation arose from her most provocative works, her art is no less provocative when it veers into less familiar terrain. As with the best contemporary artists, her pieces transcend the labels we assign to make sense of them.

At once critical and comical, reverent and subversive, expansive and succinct, bold and elusive, rigorously conceived, deeply felt, and laboriously wrought, Rachel Lachowicz's artwork revels in its contradictions. That ability to embrace opposites is not solely derived from her impressive abilities as a sculptor and her dogged, insightful response to the burdens of art history, but also from the con-

tradictions implicit in that history itself, which her work so assiduously mines. Lachowicz is best known as a feminist artist, creating sculptures that reference noteworthy artworks by (mostly male) artists of the twentieth century—works which, for all their declarative bravado, seem to waver uneasily between parody and homage. Unlike some contemporary female artists who shy away from the political or sociological implications of being called "feminist," Lachowicz wears the label proudly; at a time when identity issues feel like the faded banner of a previous avant-garde, and most younger artists would just as soon forget the battles already fought, she holds fast to the issue's relevance and urgency.

But beneath its veneer of audacious provocation, her art courts multiple meanings. Her works are seemingly wrought as much in admiration as in anger; her intent extends beyond critique, to a sort of catharsis. Her works put the issue of gender in cultural practice front and center, certainly. But beyond any didactic statement about gender and cultural production, her deeper goal is to dislodge the object in question from any preconceived historical context and highlight the absurdities and inequities behind such distinctions. And that sense of giddy liberation, the sheer glee she takes in unleashing her forms from the straight jackets that have been imposed on them through the art historical narrative that threads them, is palpable. It also goes broader than a strictly feminist construct: by taking works represented within minimalism as hard, "male," and deadly serious and re-presenting them as soft, "female," and deadpan,

Lachowicz is basically attempting to even the score. By so doing, she aligns with the anti-authoritarian impulses of the original post-minimalists, injecting pliant materials, personal imagery, and other engaged social interpretation into the formal vocabulary. (Tellingly, post-minimalism was briefly known as "anti-minimalism," as if it were a negation of the prior movement, not an evolution.) But she also stresses the sexual inequities and power politics underlying that history and thus by counterpoint symbolically regains the ideal of gender neutrality implicit in the forms themselves. As much as she is assertively a feminist, Lachowicz can also be considered as a defiant neutralist.

The irony, perhaps, is that she clearly retains a deep fascination with the reductively heroic stance and industrial authoritativeness manifested in the work of Judd, Serra, Andre, and others, despite its aura of machismo and the related gender hierarchies. And yet, with the almost concurrent emergence of both post-minimalism and the feminist movement, through the efforts of sculptors such as Eva Hesse and others, that image, and historical moment, was, in fact, obsolete almost as soon as it was forged into serial rows of metal shelves, rolled in steel, laid out across the floor in rectangular grids, or otherwise given form. Lachowicz's approach confronts that contradiction head-on, possessing that legacy as both a woman and a sculptor. She is not content to forget it and move on, to consign the gender inequities and sexual politics of the era to the musty chronicles of art history texts. Rather she embraces this legacy as joyously as Ken Burns on the fields of Gettysburg. Lachowicz's ongoing engagement with (this still recent) history—her urgency in addressing its assumptions, dictates, and untapped potential—is not just a hallmark of her work but its central mandate. Her practice is an act of rethinking and reanimating seminal twentieth-century sculptural ideas and artistic strategies as a self-consciously female sculptor, reframing them, demythologizing them, and then reclaiming them piece by piece through her labors.

In adopting makeup as her primary sculptural medium, Lachowicz has not only created her most recognizable signature device but also discovered a substance that is seemingly, in her hands, infinitely pliant and mutable. Her ingredients range from eerie, flesh-toned facial powder to a chromatic spectrum of eyeshadow, to bold red lipstick, perhaps her most jarring and arresting material. (Their malleability is also a challenge, so their deft veneer is the result of hours of laborious experimentation.) Of course, the very concept of makeup incorporates myriad meanings: it serves as a device for female beautification or, conversely, as a kind of mask or war paint; as a means to amplify archetypical gender attributes or superficial artifice; as a tool for seduction or of visual simulation and/or stimulation; or as a multi-billion-dollar consumer commodity marketed to women to help them market themselves. It is also, in its way, a quotidian if glamorous art medium through which women are invited to create an idealized self-image, using their own face and skin as canvas. It is a material of sensuality, idealization, compensation, transformation. Judgment is in the eye of the beholder: one can view it as a vehicle of female empowerment or oppression. Notably, Lachowicz's works recognize the negative connotations of the medium: the implications of superficiality, inadequacy, falseness, and conforming to a mass-market definition of feminine identity. These competing definitions of "makeup"—as device of imagination, or constitution, or reparation—freely coexist and infuse her work on every level.

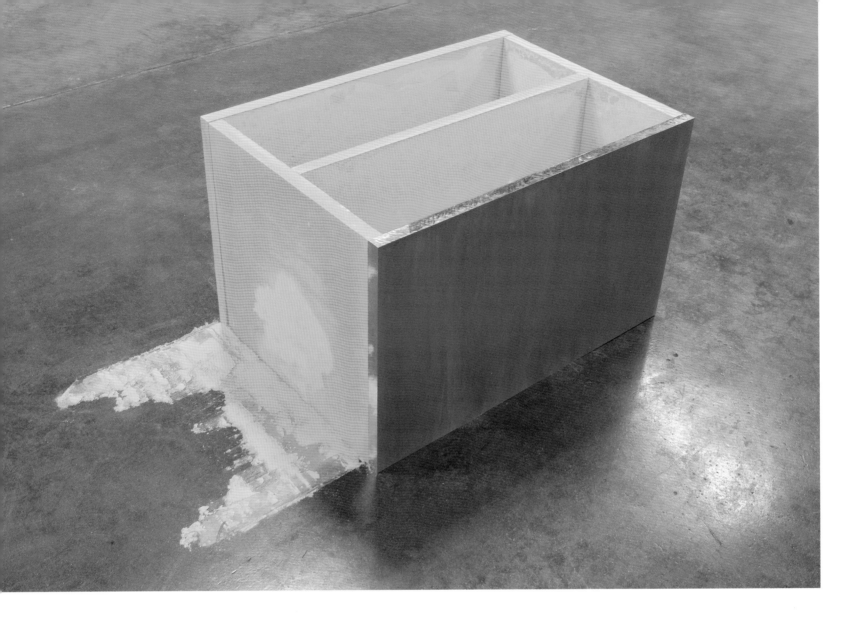

OB EX (SPECIFICALLY JUDD), 2005
PIGMENT WITH HYDROCAL, ALUMINUM
19¼ X 32¼ X 22½ INCHES
PRIVATE COLLECTION, NEW YORK

Undeniably, Lachowicz's use of such seductive materials does lend her works a certain eroticized frisson. The works are meant to be at once seductive and artificial. As with the work of Eva Hesse before her, the material's seeming pliancy helps define these objects—and define them as feminine. It imbues them (correctly or not) with an air of fragility. However, with certain notable exceptions, her ductile media do not make the works seem any more "natural" but, rather, serve to heighten their artifice. In fact, the strategy of material displacement that Lachowicz enacts goes back at least to Meret Oppenheim's celebrated surrealist fur teacup (and spoon) of 1936. It could also be compared to other post-minimalist works that employ surrealist strategies, such as Robert Gober's bronze life raft, but Lachowicz does not cull her references from the "real world." Instead, her works are symbolic reimaginings of preexisting objects from the art world: drop-dead serious funhouse substitutions that are fully transformed through her appropriative appetite and material prowess. Therein lies their trick and pleasure: her artworks function both as abstract objects and as representational depictions of abstract objects. Adopting a gamut of appropriated forms and materials, they stand on their own as fully realized entities that exist independently, even as they archly mimic their source material, like rebellious children who discover their own voice by passionately opposing the flawed but charismatic parents who engendered them.

Born in San Francisco in 1964, Lachowicz remembers visiting such art museums as SFMOMA, Berkeley Art Museum, and the de Young, among other Bay Area institutions as a child, and admiring in particular the sculpture: modernist, minimalist, and light and space art, as well as performance. (She has little memory of any representational art.) Attending CalArts, a program noted for its encouragement of cross-media experimentation, she received her BFA

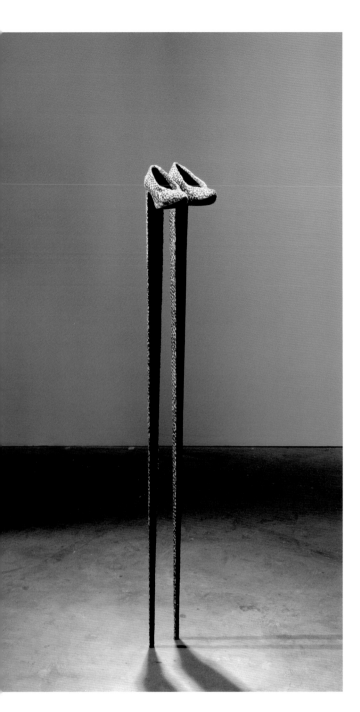

HIGH HEELS, 1991
SHOES, FABRIC, WOOD
56 X 11 X 8 INCHES
PETER NORTON

in 1988. Her early work shows her trying on the mantle of the revolutionary femme, as in her 1989 work that placed glass-bottled Molotov cocktails on a silver serving tray, and a 1990 work in which she placed a kit for making Molotov cocktails inside a coffin-like, mirrored wet-bar unit draped in white fabric. In other formative works, she paid homage to female TV stars like Mary Tyler Moore and Carol Burnett in Serra-like post-minimalist cylinders and blocks, using materials such as graphite, shredded faxes, and wood. A range of works showed her experimenting playfully with surrealist tropes, riffing on their overt forays into female objectification and inventing memorable images of her own: in 1991's *Third String,* she inset a pair of white women's shoes with the taut strings and frets of a violin neck, grouping it with an actual violin and a like-sized white violin, the neck of which has been attenuated absurdly, thereby adopting the surrealist tactic of comparing a woman's physique to that of a tuck-waisted (no doubt, tightly strung) musical instrument. In 1991's *High Heels*, she poised a pair of leopard-skin shoes on ridiculously high heels, rising off the floor to eye-level as if on tapering stalks: a metaphorical balancing act of daunting proportions.

Once unsheathed, the lipstick became a whole new, cherry-bright weapon in her arsenal. In 1989, she created *Lipstick Cube*, a modest, eight-inch-square, red-cast cube, which acted as a comment on minimalism in general but was also an obvious reference to Tony Smith. It was followed in 1991 by *Red David*, a roughly two-foot-tall, smooth red, nude male torso of plaster and lipstick, created as a sly response to Yves Klein's famous 1961 nude torso of *Venus*, which he painted the bright azure blue that since became his trademark color. Shorn of legs, arms, and heads, these competing torsos—the bright blue *Venus* claimed by the modernist male artist and bright *Red David* claimed, in turn, by the postmodernist female—make for an entirely logical, appealingly symmetrical couple despite their thirty-year age difference. (Here, it's the male who is the younger companion; score one for the cougars.) The neatness of that symmetry—"you objectify me as gender archetype; I'll objectify you"—is undeniable, and one can well imagine it must have been a revelation for Lachowicz. Her *Red David* does more than reply to Klein's *Venus*: the one work mirrors and even completes the other. In a world (or at least art world) of perfect parity between the sexes, Klein's *Venus* could not be left unanswered and unescorted.

It might be noted that previous to limiting his attentions to his own brand of ultramarine, Klein had exhibited monochromes in a range of colors, including pink and red, and that his subsequent focus on blue as his signature color had more to do with his conceptions of space, immateriality, and the void than with any conscious statement on gender. So, the Klein to whom Lachowicz is responding is at least partially Lachowicz's own historical interpretation, as indeed the other male artists she appropriates were not necessarily fully cognizant of the gender implications in their work. This case only underlines her point: as men, they had the luxury of not being fully aware. But Klein's grand gestures and glibness at claiming the female form, as in his notorious use of live, nude female models as "living brushes" in his work—and public performances—certainly make him an apt foil for Lachowicz. And it is those performances

which inspired her own 1992 Santa Monica performance *Red Not Blue*, in which she painted a nude male model in red lipstick, using him to make body prints à la Klein, then using his penis to draw a red line down the wall, claiming the male physique as her own muse and hands-on artistic tool.

Her growing facility with lipstick aside, the period from 1990 to 1993 was prolific for Lachowicz and saw her experimenting in various mediums, including works made of enamel or silkscreen on mounted glass panes, examining cultural and fashion icons, and various surrealist/minimalist hybrid installations, which allowed her to engage her succinct visual wit. These varied from a Cinderellan serial arrangement of elegant blown-glass slippers beside a pile of shattered glass (*Broken Glass*, 1992) to a Jeff Koonsian balloon bunny made of wood, which she documented, set aflame, and then charred (*Burnt Bunny*, 1993). Likewise, she expanded her exploration of cosmetics as a medium to include the fleshy intimations of facial powder and the prismatic color grids of eyeshadow. *Face Powder* (1991) culled hints of eroticism from stark minimalist geometry by setting a pair of circular structures (exaggerated patterns found on ornamental molding) cast in cosmetic powder side by side on a wall to resemble nipples, breasts, or eyes: gender signifiers that might just be staring back at you.

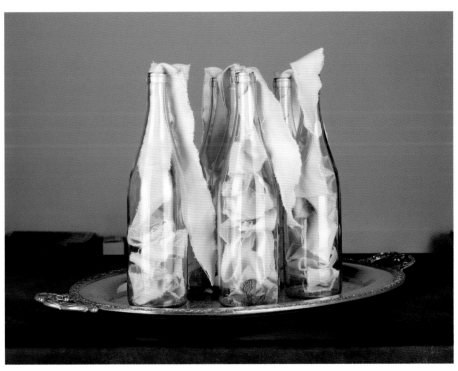

MOLOTOV COCKTAIL, 1989
GASOLINE, CANVAS, BOTTLES, SILVER PLATTER
DIMENSIONS VARIABLE
COLLECTION OF EILEEN HARRIS NORTON,
SANTA MONICA, CA

Forensic Projection (28, 58, 88 Years), from 1992, made of pale pink face powder and hydrocal, addressed a far more specific and personal subject: her own self-image. Presented in a sequence of three, the work presents a cast of her own head, which she altered through forensic forecasting and the help of a Hollywood FX expert, to depict herself at thirty-year intervals from a youthful twenty-eight to a middle-aged fifty-eight to an elderly eighty-eight. Set together on rectangular bases, the works proffer the face of the artist herself as the cultural object on display, addressing the superficial beauty standard head-on and allowing herself to be objectified as a cultural artifact, both as a woman and as an artist. A rather brave, unflinching work, it also displays the commitment with which she is able to engage her subject and her openness to casting the same investigative glare upon herself as she would on others. Beyond issues of gender objectification, *Forensic Projection* attempts to situate the artist's own identity within the serial language of post-minimalism while also presenting Lachowicz as cultural and consumerist artifact. As much as any of her works, it is very much of its zeitgeist, showing that, beyond her gender-specific art historical investigations, she had tapped into the same dynamic stream of ideas that was informing several younger artists coming out of New York and London; in a hall of early 1990s post-minimalist self-reflection, one could set it comfortably beside Janine Antoni's *Lick And*

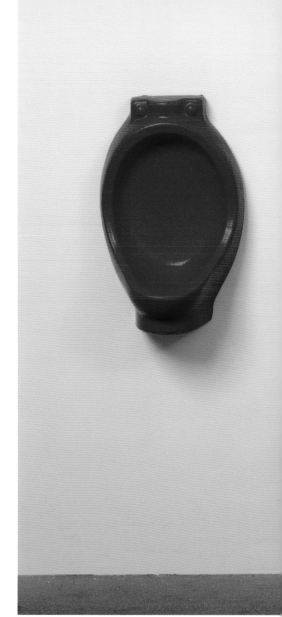

14

UNTITLED URINALS, 1992
LIPSTICK, WAX, HYDROCAL
3 ELEMENTS: 15 X 9 X 6 INCHES EACH
EDITION: 3
MARTIN Z. MARGUILES COLLECTION

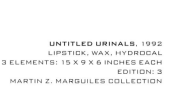

Lather (1993), in which the artist presented a corridor of self-portrait busts cast in chocolate and lard that she had worn down through usage, and Mark Quinn's *Self* (1991), which featured a life-cast of his own head, made from his own frozen blood and set on a refrigerated pedestal. Within Lachowicz's own oeuvre, *Forensic Projection* also can be seen perhaps as another reply to Yves Klein's *Venus*: by providing the missing head to the headless torso and making it her own, with her own specific features which she shows etched by time and the natural process of aging, she sets forth a starkly human female image in place of the eternally desirable, eternally youthful archetype favored by Klein—and repeated throughout art history. Looking inward, her subsequent, 1996 self-portrait *Aggregate* depicted two heads twisting violently as if being wrenched from within and made from Excedrin AM/PM, respectively. It was a drolly hilarious melding of medium and message.

At the same time, Lachowicz had found in lipstick a surprisingly malleable medium for crafting sculptures of increasing technical complexity and scale. Her imagery ranged from the explicit—a grid of wall-mounted lipstick dildos—to the suggestive—as in a pair of men's underwear cast in bright red lipstick, displayed upside down with two gaping orifices for the legs—to the clean, monolithic geometries of iconic minimalist works. In 1991, she took on Carl Andre, with a bright red six-by-six-foot grid of squares cast in lipstick and wax; it is hard to engage the work without registering the tragic fate of his wife, artist Ana Mendieta. It was followed by her take on Richard Serra in 1992's *Sarah*, a cube of four-by-four-foot planes of lipstick and wax. *Sarah* replaced the implicit tension of a violent crash in Serra's freestanding Cor-ten steel original with a reverse anxiety at how the waxy lipstick can retain its rigid form. Substituting soft materials for hard and reveling in the strength of a seemingly ductile medium has been claimed as a post-minimalist feminist strategy: investing forms seen as authoritative and industrial with a yielding, corporeal frailty. But it is also quite simply a sculptural strategy, forcing the viewer to relate to the forms from a different place within his or her own body, with a different set of sensual responses. With the Serra, you fear if you touch it, it might crash loudly with a screech of metal; with the Lachowicz, you wonder whether it might sag or buckle (would it leave an imprint of your finger?). Using the same formal vocabulary as the Serra, the Lachowicz invites a contrasting physical reaction; the work is equally as off-limits as the Serra but more exposed and without the threat of violence. In a way, Lachowicz's reinvention has less to do with the organic geometries of Eva Hesse than with the perceptual gamesmanship of Los Angeles conceptual sculptor Charles Ray, whose daring reworkings of minimalist cubes in the late 1980s compelled

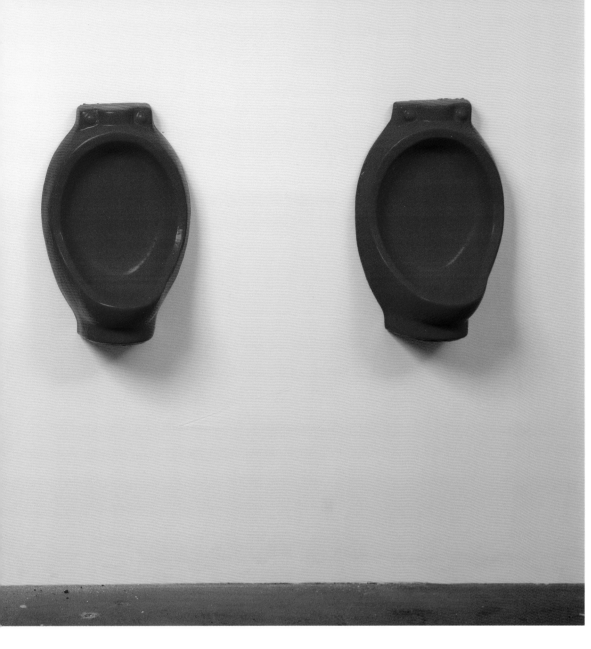

viewers to gauge the disjunction between the forms, the materials that compose them, and one's bodily response to them.

Her tongue-in-cheek take on Duchamp, a set of three cartoony urinals cast in lipstick, wax, and hydrocal (*Untitled Urinals*, 1992), is no less provocative. In this case, she transforms the ultimate snarky readymade—Duchamp's 1917 *Fountain*—into a gaggy consumer item and incites uneasy allusions to open mouths. In the spirit of cross-gender parody, it also references Sherrie Levine's polished bronze urinal of 1991, thus appropriating the appropriator, turning her gilded upscale treasure into something far more commonplace and unsettling. At once humorous and vaguely creepy, the work ranks among her edgiest satires, daring you to laugh but then prod-ding you to journey back up the art historical flowchart, to mull the source and meaning of our art historical icons and the degree to which they can be seen anew when suitably reframed.

In fall 1992, Lachowicz was given a solo exhibition at the Newport Harbor Art Museum (since merged into the Orange County Museum of Art). But it was a group show at another museum two years later, in 1994, that helped define her context even more memorably. Assembled by curator Lynn Zelevansky at the Museum of Modern Art (MOMA) in New York, *Sense and Sensibility: Women Artists and Minimalism in the Nineties* brought together seven young-to-mid-career female artists who engage the post-minimalist legacy and lexicon. Initially, the hubbub that greeted the show was based around the fact that it had been installed in the building's rather cramped basement gal-lery, which the museum was hoping to use more prominently but which was interpreted as a gender-tinged slight. But despite its placement and a few glaring omissions, the show found a reasoned, rigorous way to gather a group of women artists who employed a diverse but overlapping set of strategies. One might call that collective attitude—although Zelevansky was too classy and judicious to do so—for lack of a better term, "feminimalism."

Including artists such as Polly Apfelbaum, Mona Hatoum, Rachel Whiteread, and Andrea Zittel, the exhibition cast a wide net in both formal and conceptual viewpoints represented. Revisiting such minimalist strategies as serial-ity, modularity, repetition, grids, and geometry, with lighter and more pliant materials, more personal approaches to object making, greater interest in domestic space, as well as social and political awareness as informed by the women's

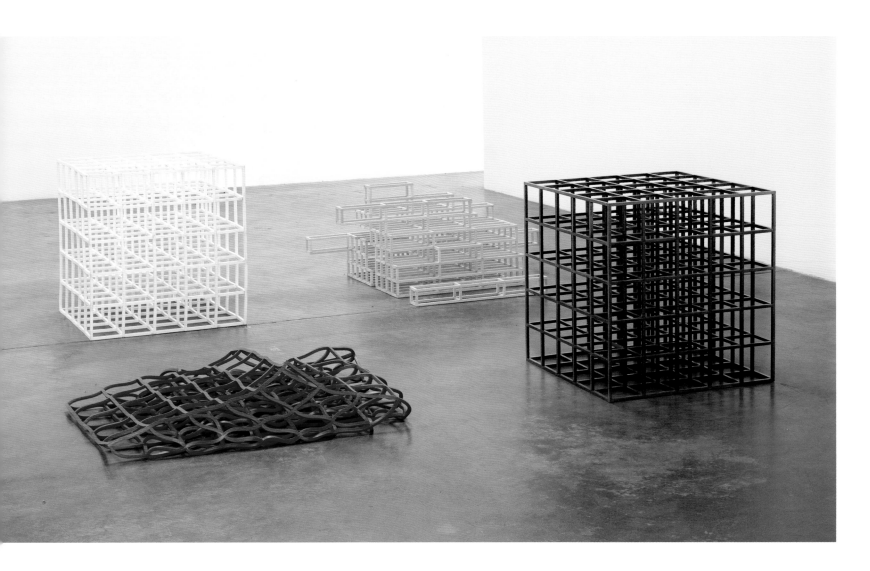

movement of the '70s (and other sources), the brand of post-minimalism on display was far from uniform. Indeed, of all the artists, Lachowicz was and remains the one most overtly identified with feminism, the one most clearly a "feminimalist." But her feminimalist impulses are filtered through an equally genuine admiration and affection for the historic artworks she confronts. Even when addressed head-on, more often than not, they found voice in blunt but haunting metaphors, as in *Coma* (1991). It features six cubical bird cages, coated in lipstick and suspended by filament, and was among the works displayed at MOMA. As with her sister post-minimalists, she simultaneously embraces and subverts the heroic aspects of minimalism, which makes for a compelling high-wire act.

Given the meta-referentiality implicit in Lachowicz's appropriative instinct, it is unsurprising that as she evolved her language, she continued to add on new layers of complexity. In her 1995 show at New York's influential Fawbush Gallery, she invoked, among others, Allan McCollum, whose works examine themes of mass reproduction and individuality, by cloaking one of his standing vases in a sewn raincoat and hat. They were among other art objects she reassigned to dresses. The impulse came from a photograph she saw of Ellsworth Kelly making a dress out of scraps in his studio. As part of his inquiry, McCollum invites viewers to assign their own projections to his multiples of vaguely figurative vases; Lachowicz takes him up on the implicit offer, bringing "feminine" issues of craft and fashion into the equation. More than merely appropriation, her work thus becomes almost a form of collaboration. In her 1996 show at Shoshana Wayne in Santa Monica, she took on Sol LeWitt, who, despite his integral role in developing minimalism and conceptualism, had stripped back the proposed authorship of the artwork to the act of conceiving the rules for its creation—while permitting others to construct it according to his preset regimen. In her rule-bending collaboration, she lays out several ways to subvert the artist's intended equations, casting one modular cubic grid in white rubber so

A NOTE ON SOURCES:

The primary source that I refer to in writing this essay is, ultimately, the artist's own ongoing body of work, which I have had the chance to observe firsthand for nearly two decades. In this essay, I have thus approached her work with an experiential mandate, engaging it more for its sculptural savvy than for its ideological import. I first began a dialogue with Rachel in 1993, when I wrote an article on her and two other female artists, for VOGUE magazine; in 1994, I saw her work at MOMA in the group exhibition Sense and Sensibility: Women Artists and Minimalism in the Nineties, curated by Lynn Zelevansky. Zelevansky's catalogue essay for that exhibition was an integral reference to me in writing this essay, especially as it touches on post-minimalism, its history, and its diverse feminine iterations. While writing this text, I also read Louise Nevelson: A Passionate Life, by Laurie Lisle (1990, New York: Summit Books); although the book is not cited overtly, it seeped in implicitly, giving potent account of Nevelson's complex persona within the male-dominated art world of the era. The quotes on Schwitters come from a 1968 essay by John Coplans, with Walter Hopps, for the UC Berkeley Press, as reprinted in Provocations: Writings by John Coplans (1996, London: London Projects). The Bruce Guenther quote is taken from a 1999 catalogue essay for a monographic show on Lachowicz he curated at Peggy Phelps Gallery at Claremont Graduate University. Additional source material chronicling the arc of Lachowicz's career was provided by Shoshana Wayne Gallery, and by Lachowicz herself, in the form of a few select writings and impressive photographic documentation. The piece was also informed by an interview with Rachel at her Santa Monica studio in April 2011, as well as several follow-up e-mails with her to clarify certain biographical, technical, or conceptual questions that I had regarding her work. I am thankful to the artist for her faith to relate and interpret her artistic journey, and for inviting me to participate in the feminist dialogue as an unabashedly heterosexual—if not quite heteronormative and, I hope, not-too-patriarchal—male writer.

that it shudders and bounces at the viewer's proximity, as another, made of red silicon rubber, slumps across the floor like melted lipstick. In their candid use of quotation and active reinterpretation, she admits a certain coauthorship with the original artists while asserting her right to adopt and adapt them through other artistic or gender-based practices, leaving them suspended in a state of uneasy hybridity. Demystifying the originals, she nonetheless invests them with a new aura of mystery through their subversiveness, eccentricity, droll humor, and sheer, tactile presence.

Lachowicz's use of eyeshadow, which has remained a central element in her practice for two decades, has given her work a crafty means of referencing painting in a sculptural guise (as well as a range of beguiling color options). It began in 1992, with a pair of *Color Charts* based on the 1966-74 series by Gerhard Richter, who had adopted the banal device as a color-driven readymade. In his dismissal of ideology, Richter had selected the format as a neutral template; Lachowicz's feminized rendering injects the work with an implicit belief system that Richter had deliberately filtered out. In ensuing shows, the canon was expanded to include Ellsworth Kelly, Frank Stella, Agnes Martin, among many others. Delving into portraiture, she memorably adapted a mammoth grisaille self-portrait of Chuck Close, in 1998-99, and a few years later, followed it with a Close portrait of John Baldessari, pushing her exploration of authorship and "claiming" of artistic male role models with calculated aplomb. In her take on Lichtenstein's *Temple of Apollo*, she went so far as to eliminate the work's ostensible subject, reducing it to a bifurcated grid of Ben Day dots: atomizing his already reductive high/low classical ruin to its elemental syntax. In fact, Lachowicz has a right to claim both (later) Close and Lichtenstein as precursors, at least in the formal strategy of constructing their imagery from compilations of smaller units, dots, or cells: in using discrete makeup containers as her basic compositional units—her feminimalist DNA—Lachowicz blatantly exposes her artworks' sleight of hand; whatever art historical "image" they present, they are clearly, intentionally visible as the sum of their parts. Like Ricky Jay or Penn & Teller, she simultaneously debunks such trickery and runs with it.

Likewise she has studiously reproduced Warhol's poppies as multiples, in eye-popping color variants, à la Warhol, from periwinkle blue to viridian green to quinacidrone rose, making explicit the decorative, fashionable, "factory" aspects of the work. Ironically, Warhol's "originals" were rolled out as multiples, while her painstakingly crafted simulations are unique. To emphasize their sculptural, spatial aspects, Lachowicz has, in the past half-dozen years, increasingly urged her works into three dimensions, as in her 2005 show at Shoshana Wayne and 2006 show at Patricia Sweetow in San Francisco, with works such as *Kline Curve*—in which the central plane seems to roll up off the wall like an unpinned canvas—*Mondrian Bulge*, and *3D Stella*. In recent years, she has adapted works by Dan Flavin and James Turrell, translating the experiential effects of the light and space movement into brazenly concrete objecthood, dispelling and demystifying their ineffable illusions.

Her recent 2010/2011 solo show at Shoshana Wayne was as dynamic and succinct as any in memory, and it showed her smartly flexing her well-honed feminimalist muscles. Two hefty wall sculptures facing each other across the gallery— one, a cardboard working model, the other composed from various shades of blue eyeshadow encased in Plexiglas— conjured a gamut of references, from female sculptural pioneers Louise Nevelson and Lee Bontecou, to Kurt Schwitters's

Merzbau. Schwitters, one of the essential innovators in twentieth-century art, marks a compelling choice, with his ardent embrace of collage and novel use of materials; *Art Forum* founder Coplans notes his works' "disjunctive" mode of composition and having "a palpable sense of agglutinization: of creating structure by a series of accretions"—which finds intriguing echoes in Lachowicz's own. The baby blue pigment suggests a nod to her old foil Klein, claiming blue as a feminine color and finding in it Kleinian suggestions of infinitude.

Two large modular sculptures dominated the center of the room: a cylindrical construct of cast pink soap scented subtly with fragrant bergamot in oblique reference to Mary Cassatt, and a rectangular Judd- or Andre-like stack of forty-eight black metal shoeboxes, holding tissue paper branded with her signature: a wryly chic fusion of feminine delicacy, consumerist glamour, and a tongue-in-cheek statement of authorship. More formally akin to minimalism than most of her work, set together, these pieces almost take on the aspect of architecture—ramparts, wall, and well—a set of carefully wrought landmarks to mark her passage forward from the rich but problematic landscape of the past.

In 1999, curator Bruce Guenther described that journey as an evolution "from brash parody to highly nuanced critique." Since then, Lachowicz's facility has only deepened. Ironically, today a new generation of artists, from Los Angeles and elsewhere, are engaged in appropriating (or, one should say, "sampling") modernist tropes, having experienced them mostly indirectly, as art history. However, Lachowicz remains unique in the degree to which she rethinks and reframes such sources, then reimagines them with such indomitable, concrete physicality. At first blush, her strategy appears hyperrational and highly analytical, but once you get past its symbolism, it is also deeply intuitive and almost obsessive. That passion is contagious despite the works' cool surface, and it fuels them from within.

Rather than calling her "postmodern" or "post-minimalist," perhaps it is most useful to think of her works as "post-ironic." Geared more toward parity than parody, they are highly self-aware, posed between sincerity and irony—that is, they are both sincere *and* ironic, and she thinks enough of her viewers to assume they will accept the paradox. Her work is haunted by history, perhaps even daunted by it somewhat, and determined not to be. As cultural commentary, her creations are always looking over their shoulder to the achievements and inequities of the past while looking longingly up ahead, to a more perfect future, defined by their own, longed-for obsolescence. But they are also hopeful, finding in that same anxious legacy a cornucopia of formal, strategic, and aesthetic inspiration. In claiming these works for herself as a contemporary female sculptor, she is ultimately claiming them for anyone who would fully engage them. Beneath her critical mien and declamatory wit flickers the cheerful, fuck-it-all grin of someone who has kicked open the attic door, to reclaim the legacy of her precursors on her own terms.

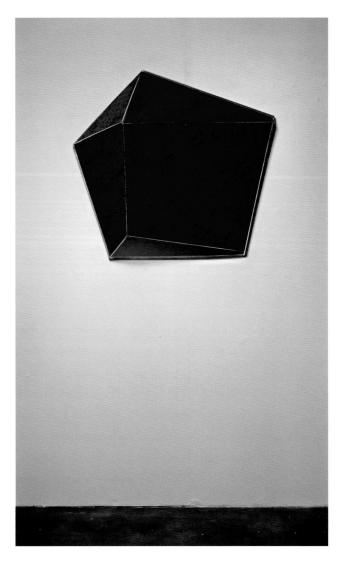

INDEPENDENT CELL, 2012
PIGMENT—COSMETIC COMPOUND, PLEXIGLAS
36 X 42 X 11 INCHES

PLATES

in loose chronological order

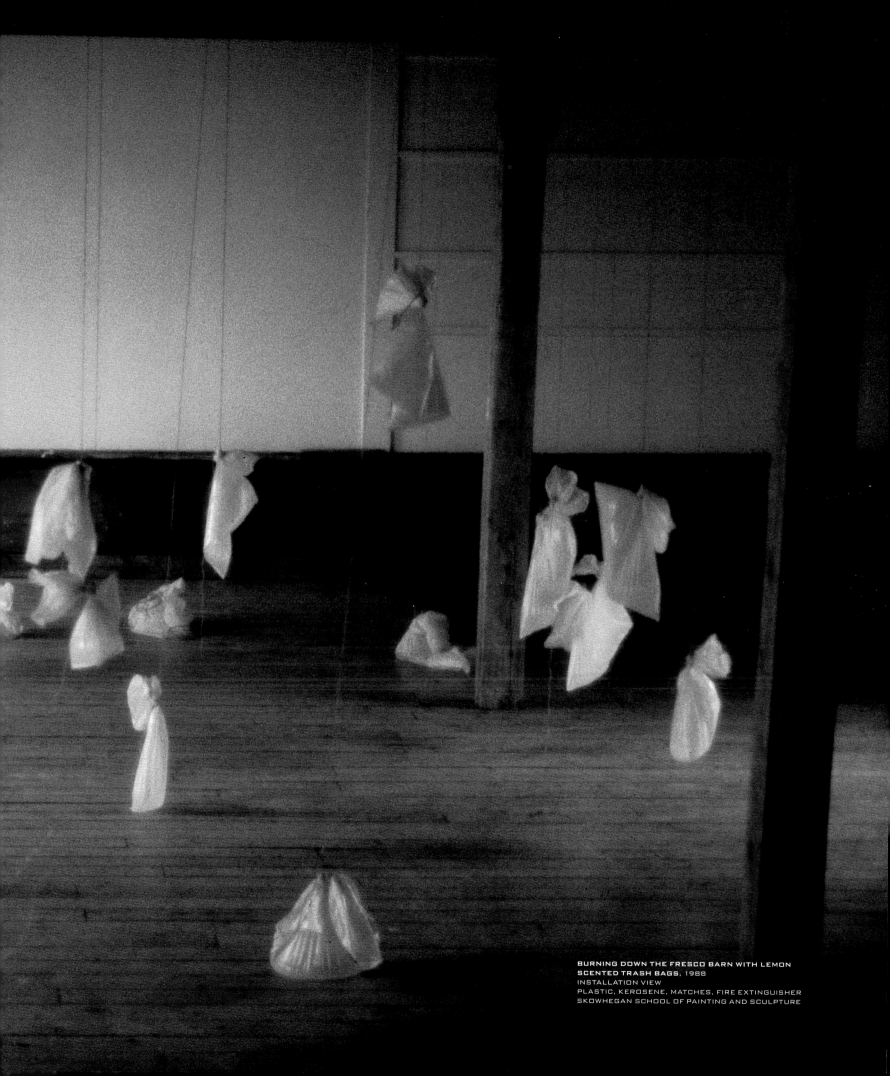

BURNING DOWN THE FRESCO BARN WITH LEMON
SCENTED TRASH BAGS, 1988
INSTALLATION VIEW
PLASTIC, KEROSENE, MATCHES, FIRE EXTINGUISHER
SKOWHEGAN SCHOOL OF PAINTING AND SCULPTURE

22

UNTITLED, 1988
METAL
27 X 72 X 72 INCHES

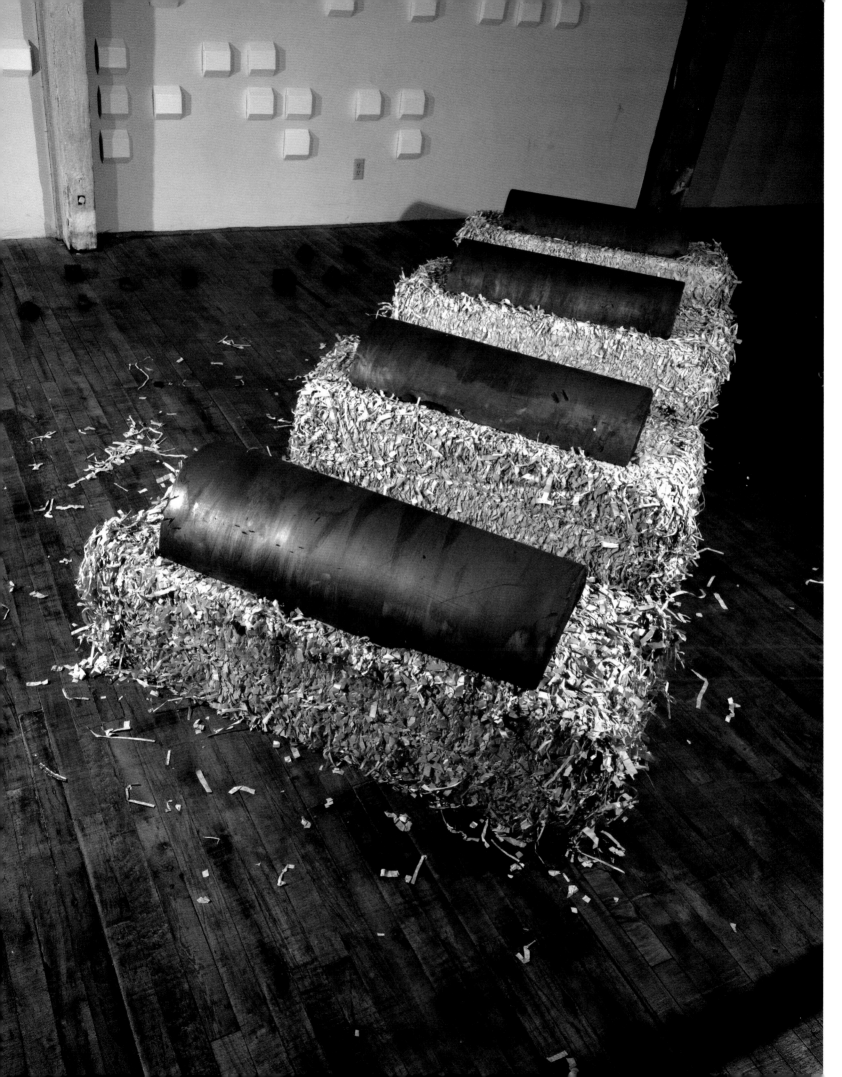

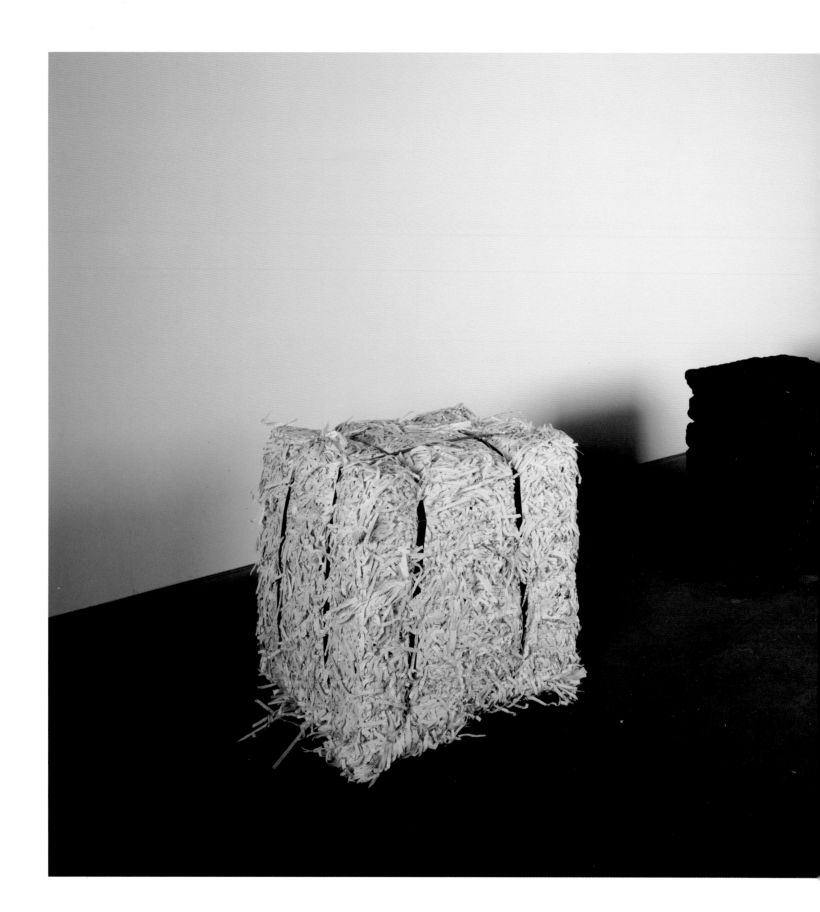

CAROL BURNETT, 1990
WOOD, CHARCOAL AND PAPER
3 ELEMENTS: 2 X 2 X 2 FEET EACH
GIFT OF BETTY AND BOB KLAUSNER
ART, DESIGN AND ARCHITECTURE MUSEUM, UC SANTA BARBARA, 1994.16.A-C

MARY TYLER MOORE'S HAIRDO, 1988
PAPER, GRAPHITE, WEIGHT
GRAPHITE: 27 X 12½ (DIAMETER); PAPER: 2 X 2 INCHES

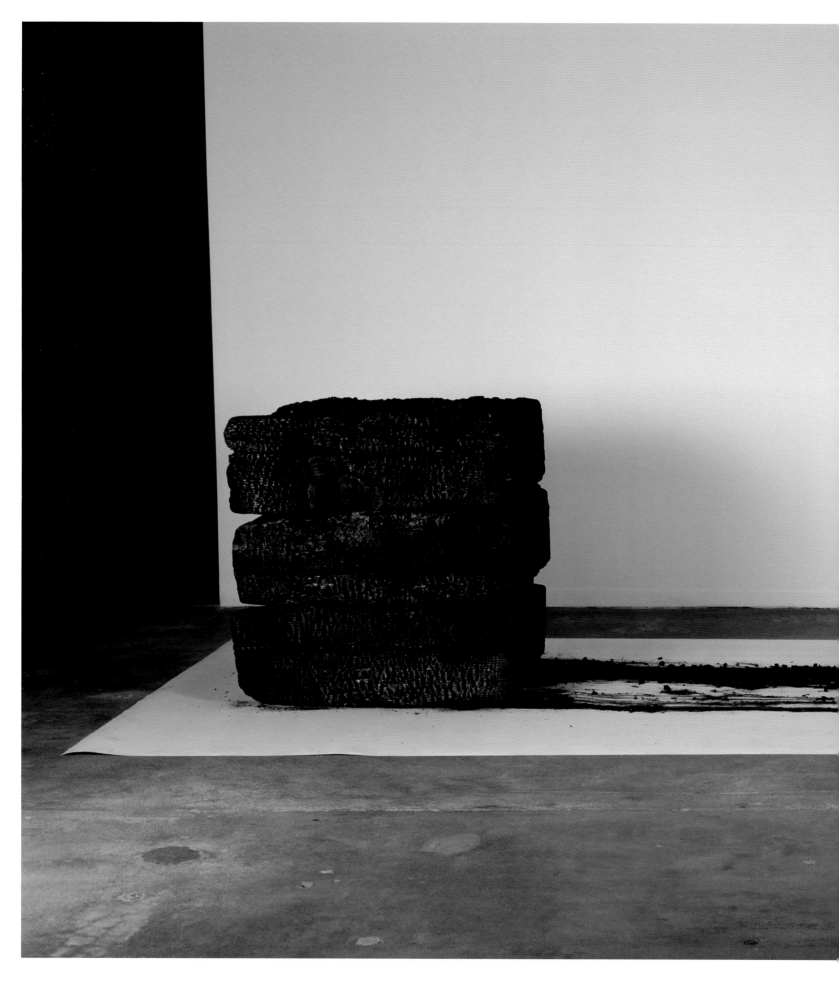

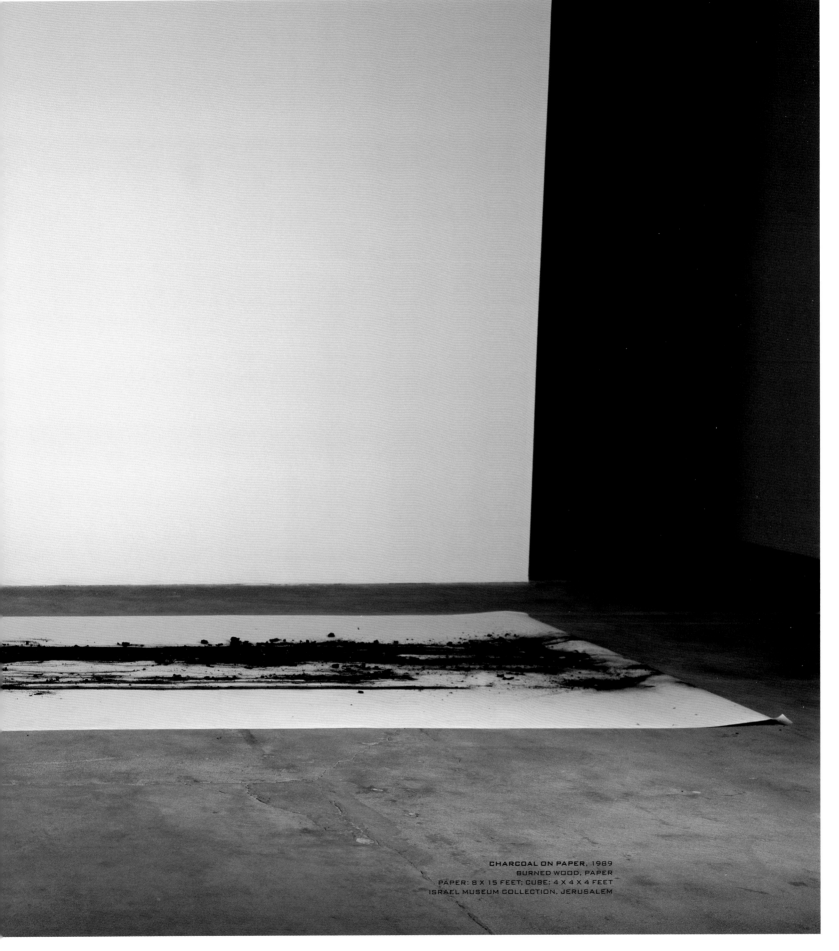

CHARCOAL ON PAPER, 1989
BURNED WOOD, PAPER
PAPER: 8 X 15 FEET; CUBE: 4 X 4 X 4 FEET
ISRAEL MUSEUM COLLECTION, JERUSALEM

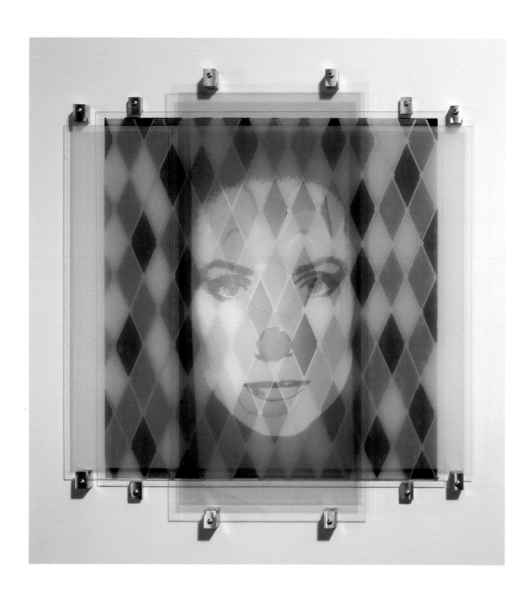

28

CATHERINE (AFTER CATHERINE DENEUVE), 1991
ENAMEL ON GLASS
27½ X 26 INCHES
PETER NORTON

COLLAGEN, 1990
CAST LIPSTICK MOLDING
3 X 192 INCHES

FACE POWDER, 1991
CAST FACE POWDER, PLASTER
2 ELEMENTS: 23 INCHES (DIAMETER) EACH
COLLECTION OF CRAIG ROBINS

WISH YOU WERE HERE, 1990
SANDBLASTED MIRROR
16 X 52 INCHES
PETER NORTON

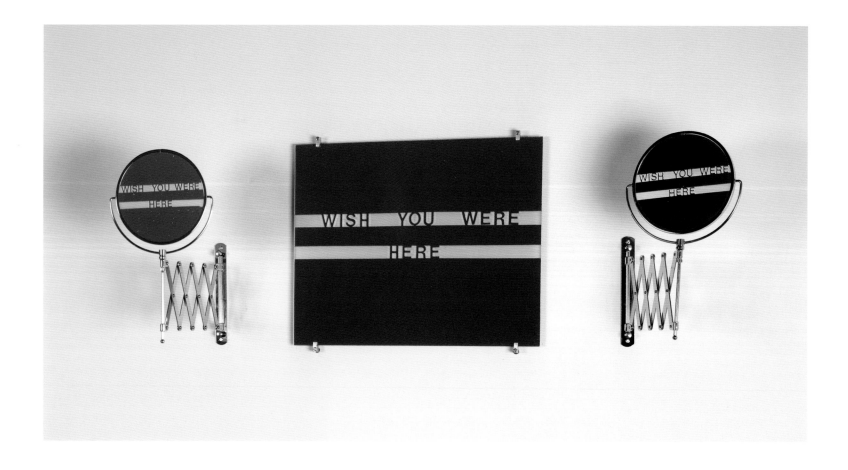

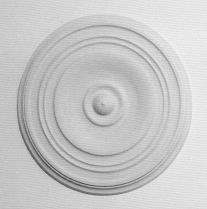

COMA, 1991
BIRDCAGES, LIPSTICK
6 ELEMENTS: 13 X 12 X 11 INCHES EACH
INSTALLATION: VARIABLE
COLLECTION OF BIL AND RUTH EHRLICH

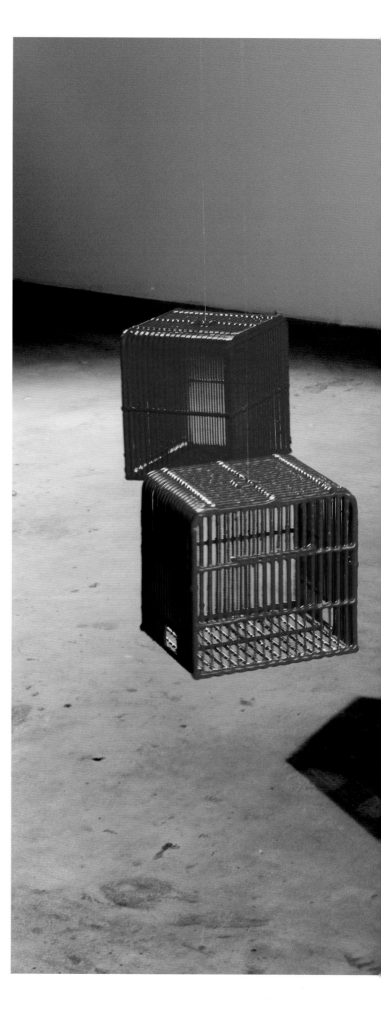

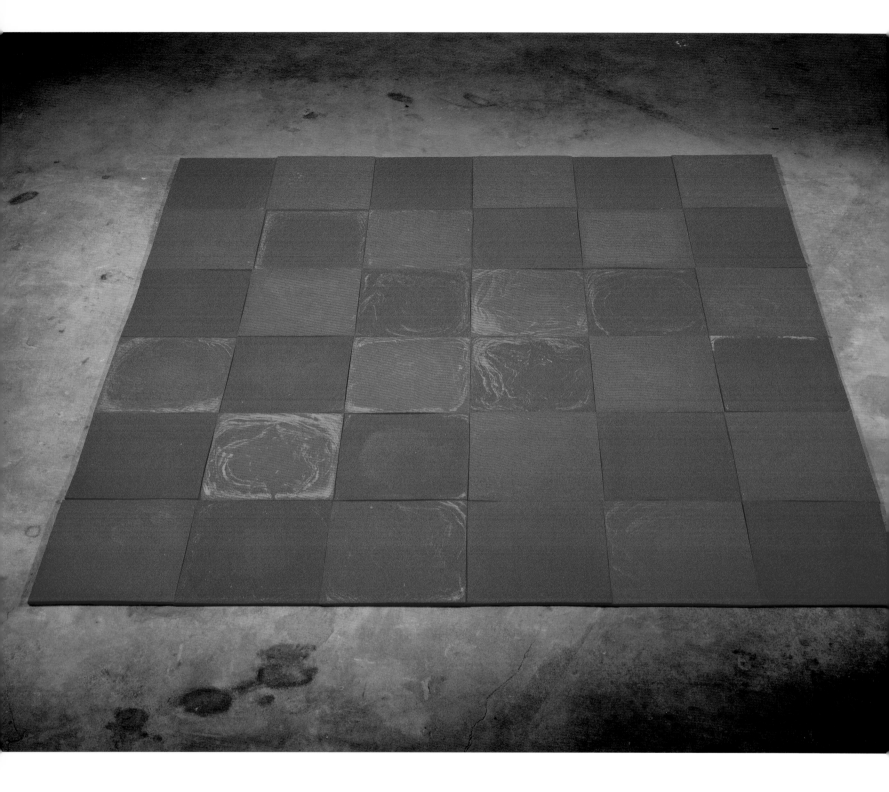

HOMAGE TO CARL ANDRE, 1991
LIPSTICK, WAX
3/8 X 72 X 72 INCHES
ORANGE COUNTY MUSEUM OF ART

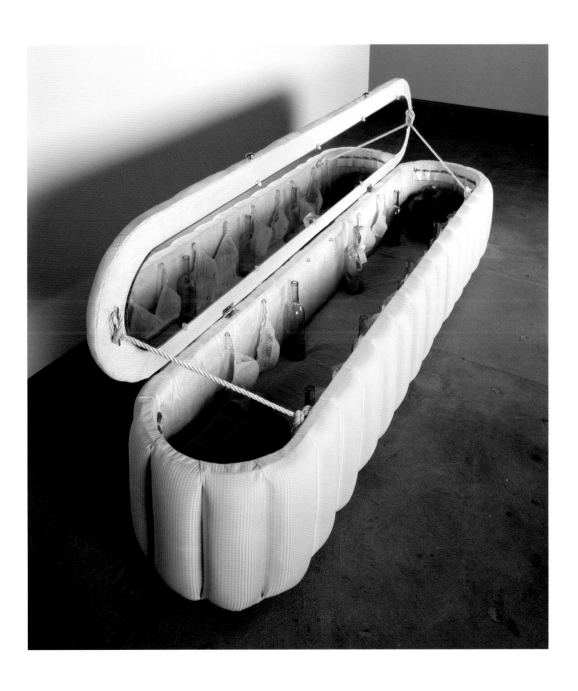

MOLOTOV COCKTAIL KIT, 1989
FABRIC, GAS CANS, MATCHES, CANVAS
18 X 96 X 24 INCHES

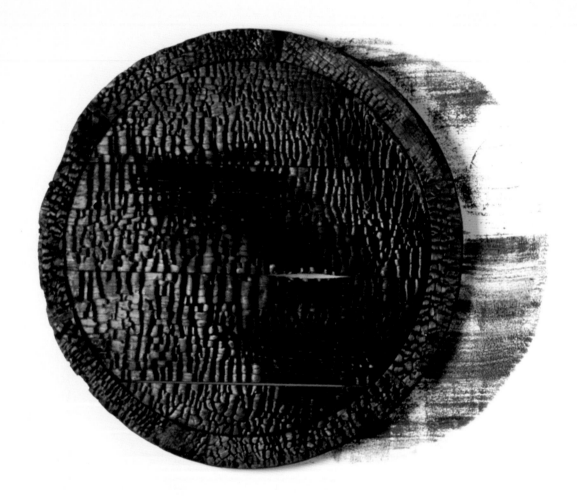

BEAUTY MARK, 1990
CHARCOAL, BLUEPRINT, GLASS
CHARCOAL: 32 INCHES (DIAMETER); SILKSCREEN ON GLASS: 36 X 36 INCHES

38

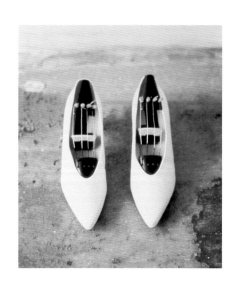

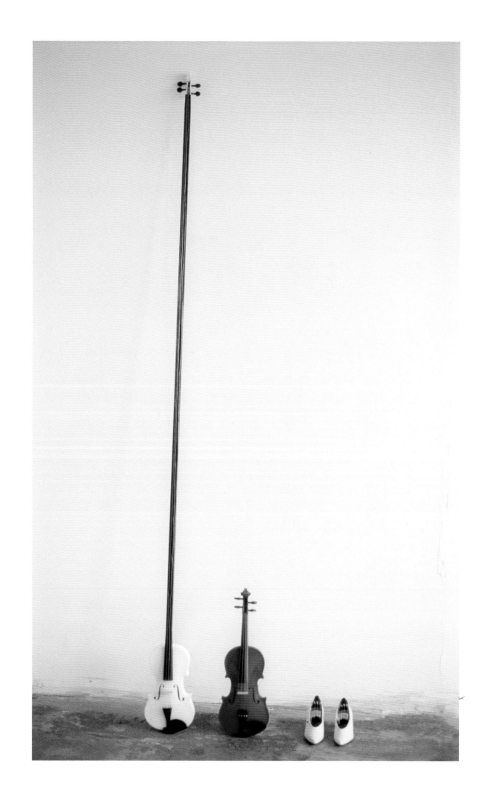

FEMME FATALE, 1991–92
COSMETIC POWDER, PLASTER, METAL HOOKS, ROPE
DIMENSIONS VARIABLE
PRIVATE COLLECTION

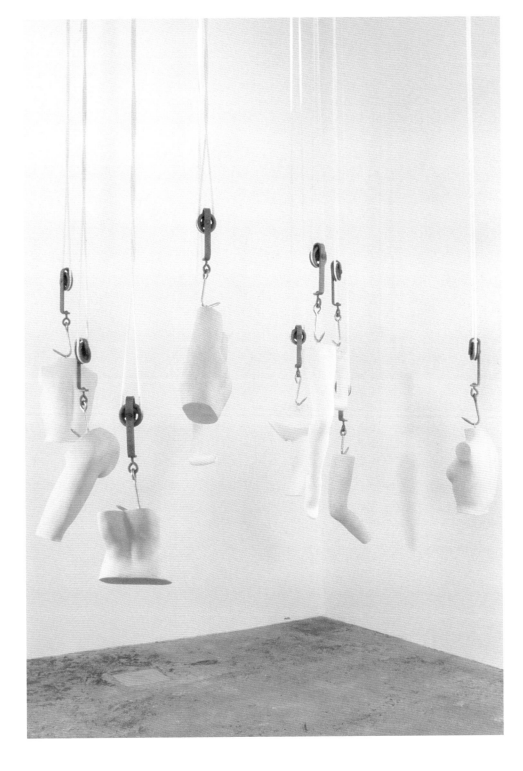

40

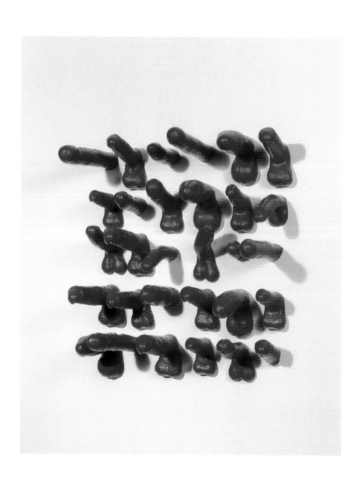

MONOCHROME RED, 1991
CAST LIPSTICK
20 X 20 INCHES
THE GINNY WILLIAMS FAMILY FOUNDATION
THE COLLECTION OF GINNY WILLIAMS

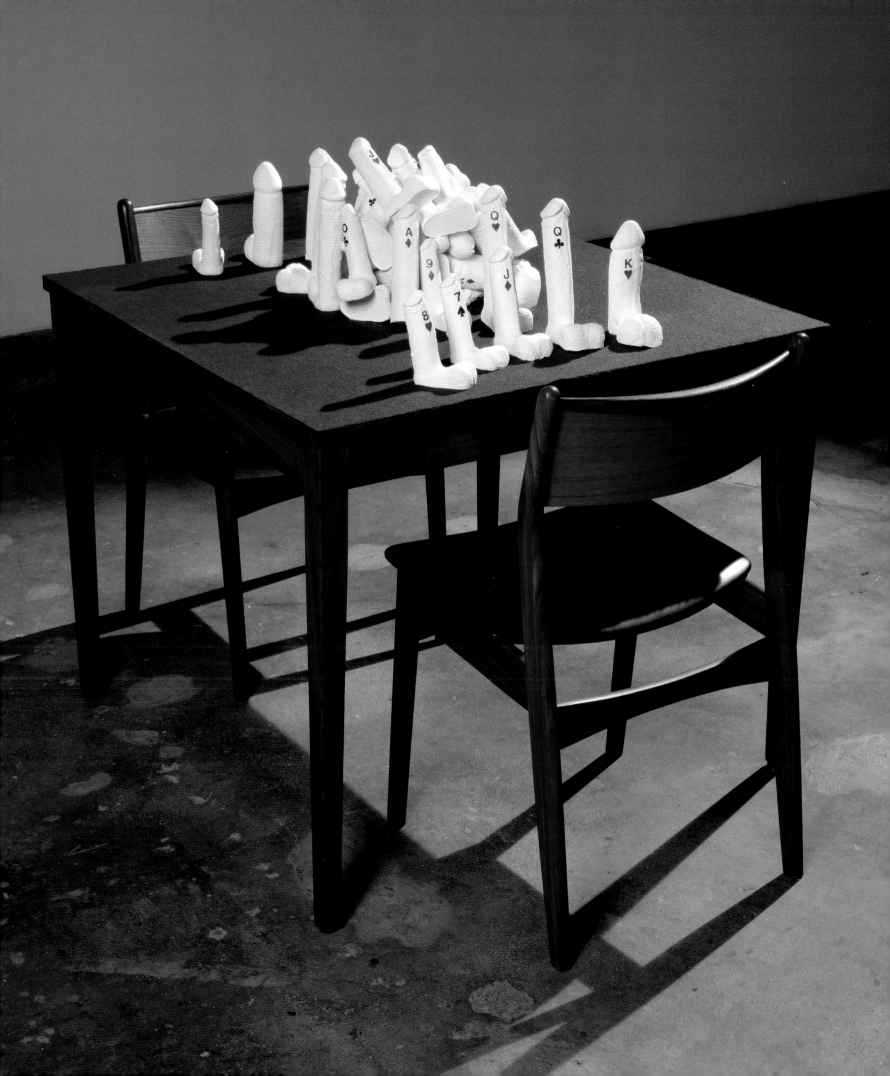

PINK AND BLUE, 1992
LIPSTICK, FIBERGLASS, FABRIC
26 X 11 X 4 INCHES; 27 X 16 X 11 INCHES
TOM PATCHETT, LOS ANGELES

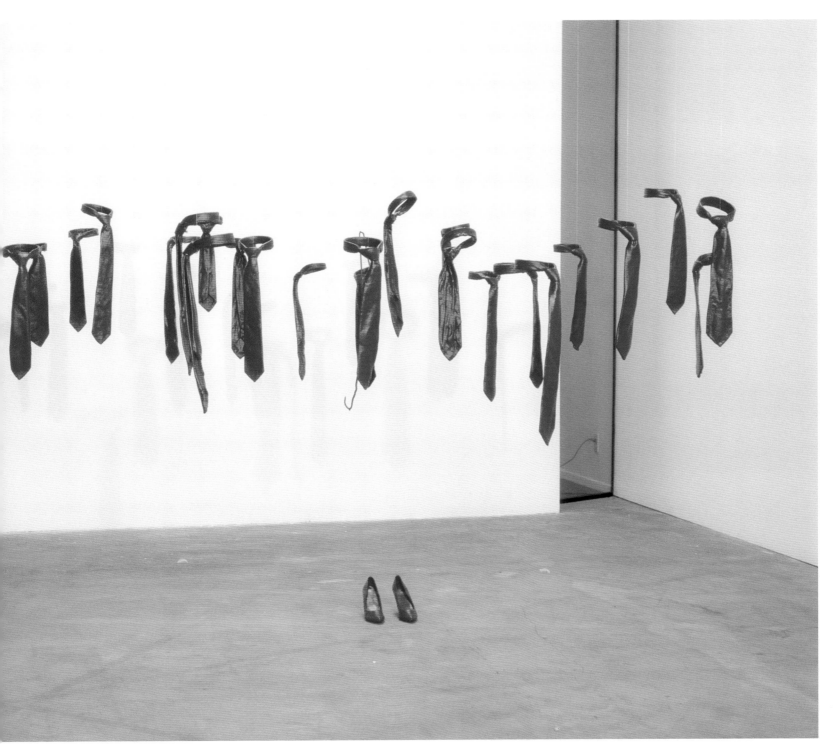

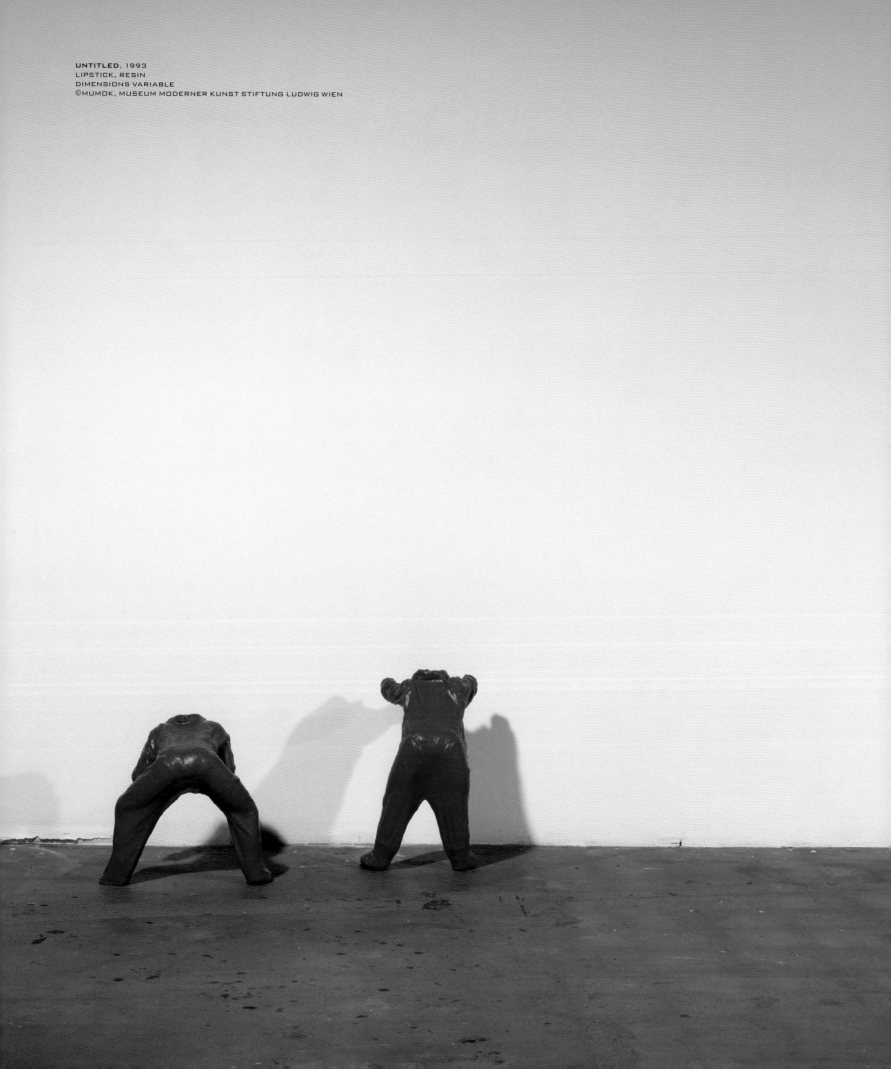

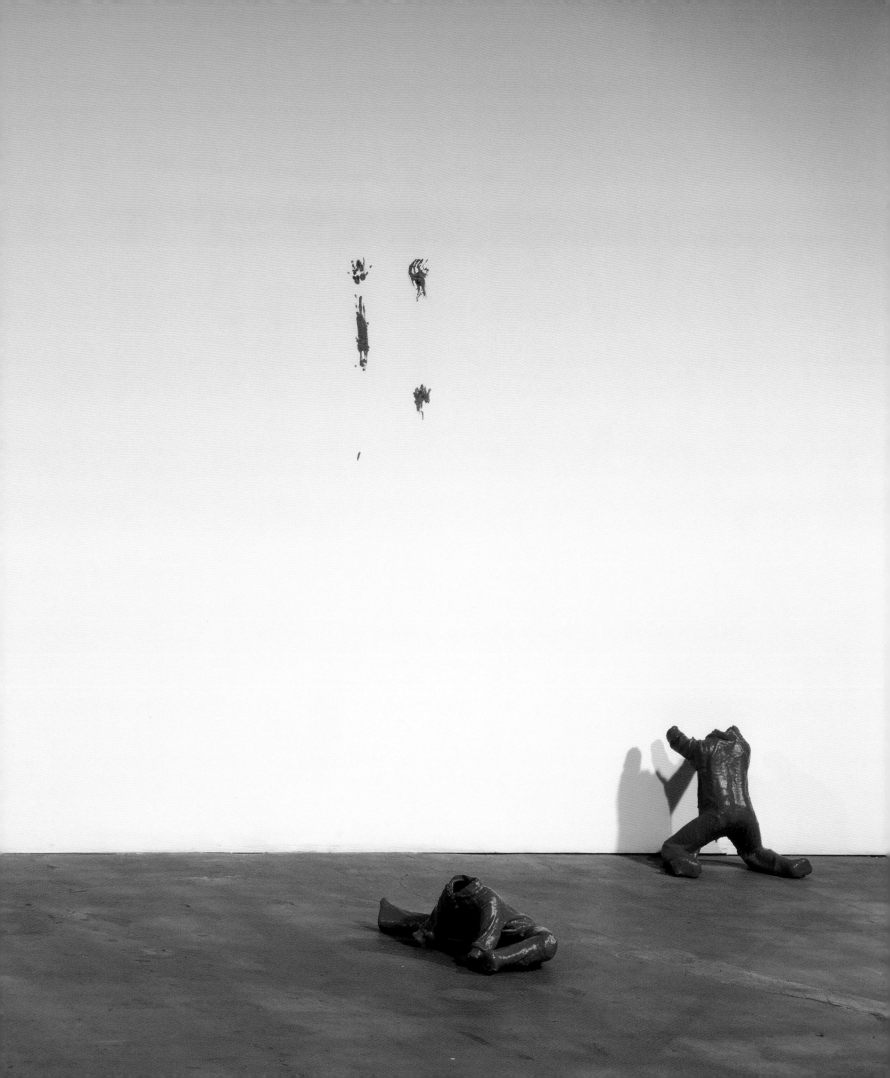

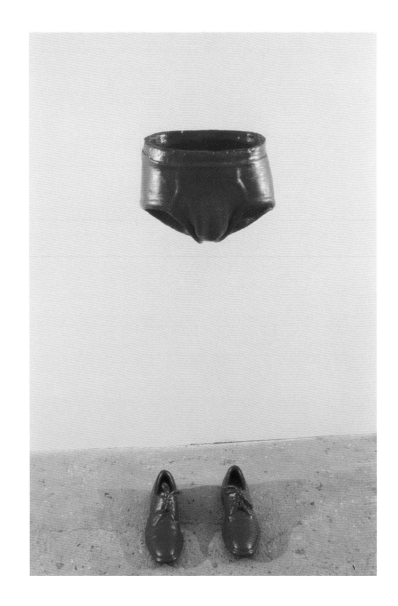

RED TIPS, 1991–92
LIPSTICK, FABRIC, RESIN, SHOES
44 X 14 X 12 INCHES
THE SPEYER FAMILY COLLECTION, NEW YORK

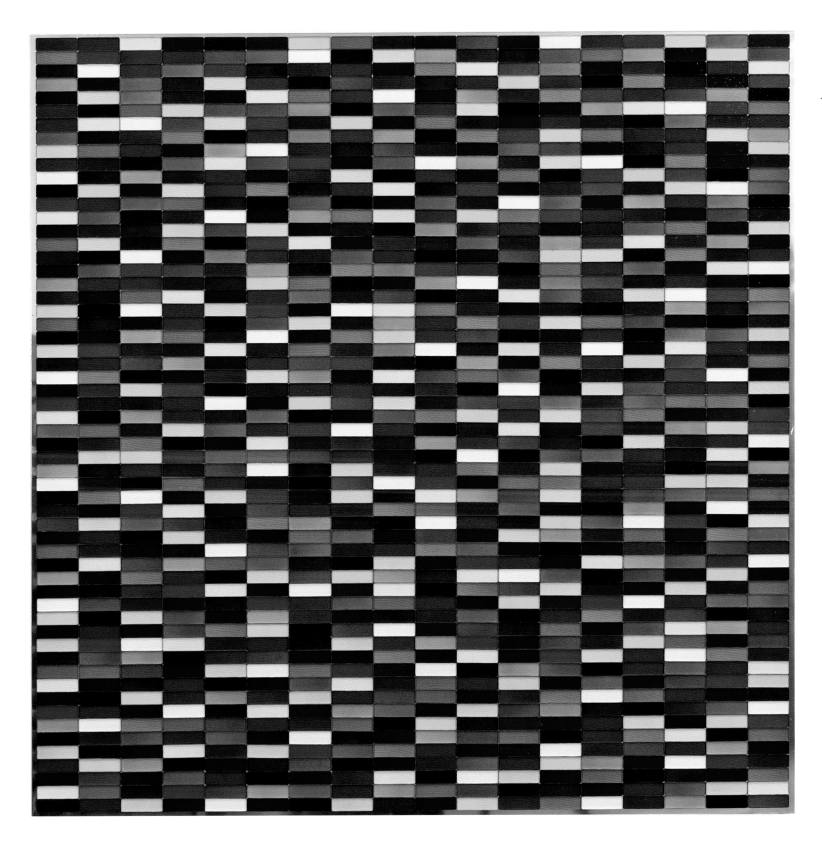

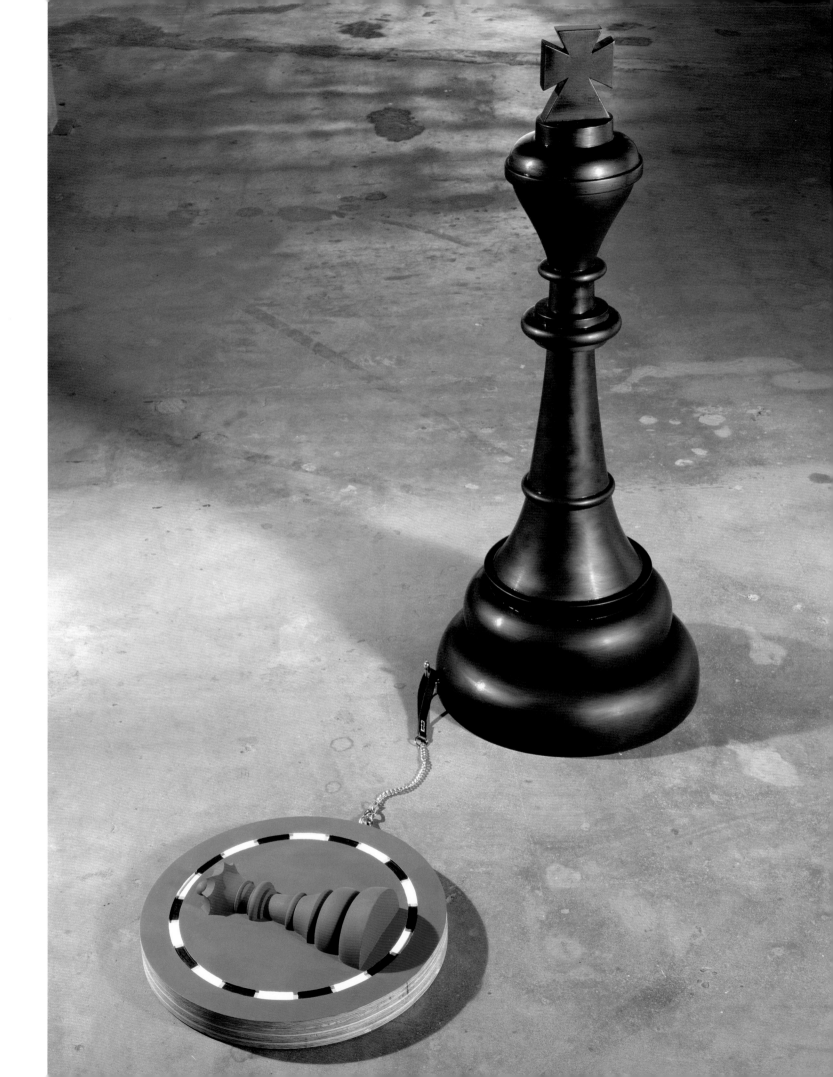

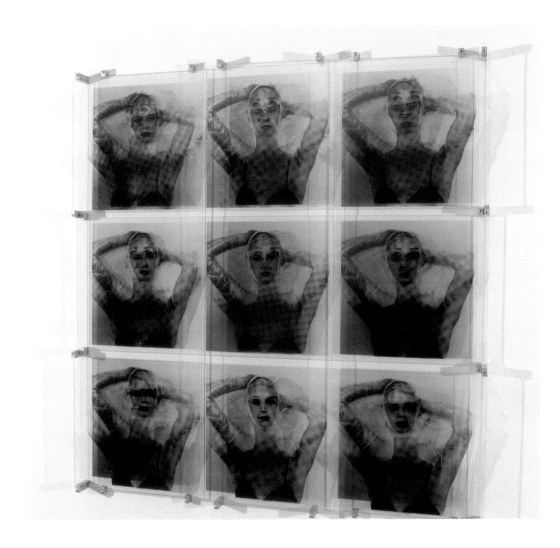

UNDER THE INFLUENCE, 1992
INK ON GLASS; 6 PANELS; 24 ALUMINUM BRACKETS
44 X 44 X 12 INCHES
MUSEUM OF FINE ARTS, BOSTON

BLACK AND BLUE, 1992
WOOD, PIGMENT, LEASH
KING: 49½ X 20½ INCHES (DIAMETER); QUEEN: 6 X 20 INCHES (DIAMETER)
COLLECTION OF EILEEN HARRIS NORTON, SANTA MONICA, CA

50

SARAH, 1992
LIPSTICK AND WAX
48 X 48 X 48 INCHES
COLLECTION OF REBECCA AND ALEXANDER STEWART

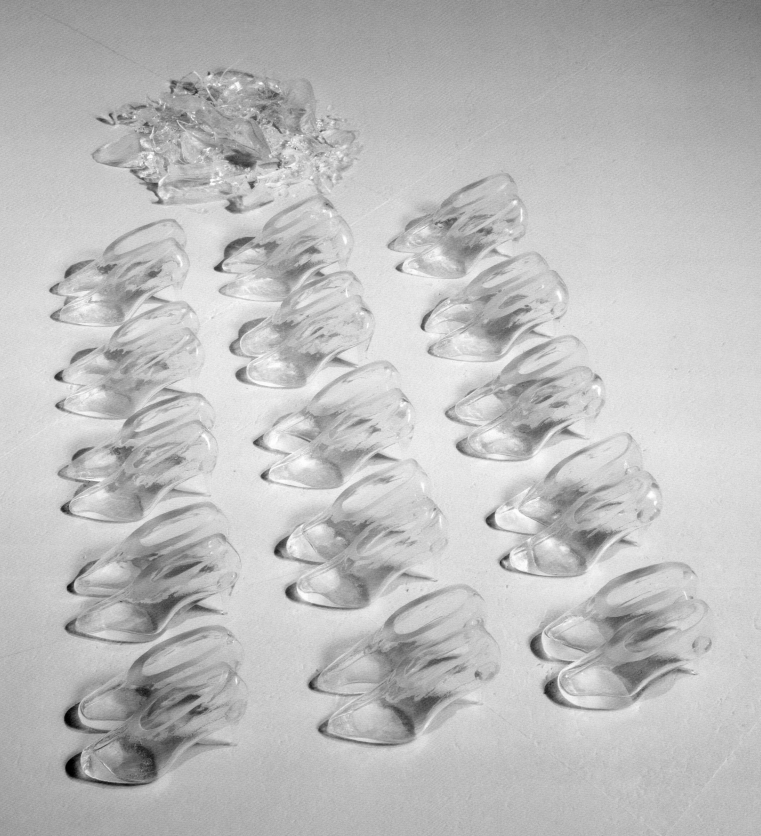

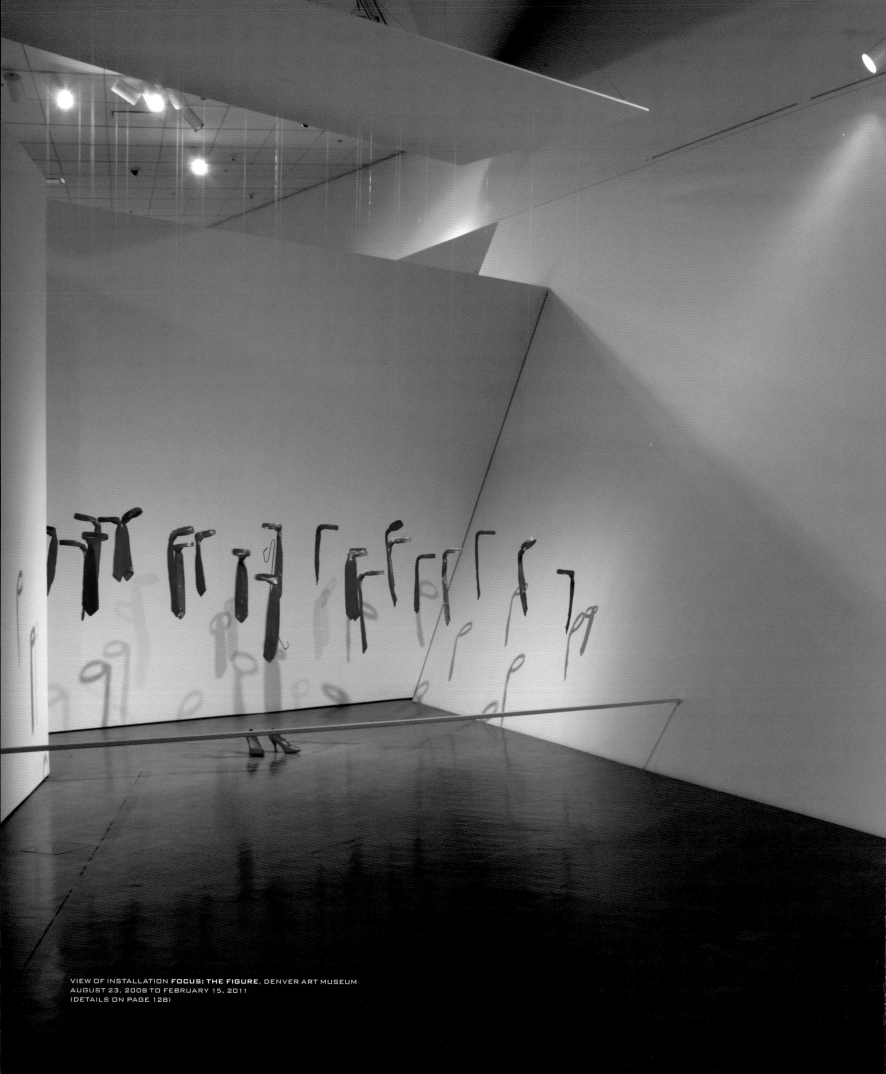

VIEW OF INSTALLATION **FOCUS: THE FIGURE**, DENVER ART MUSEUM
AUGUST 23, 2008 TO FEBRUARY 15, 2011
(DETAILS ON PAGE 128)

VICKI & KENT LOGAN GALLER

by AMELIA JONES

NOT:
RACHEL LACHOWICZ'S
RED NOT BLUE, 1992

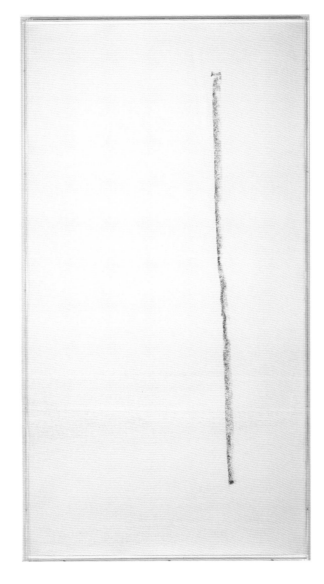

I WAS INVITED TO RACHEL Lachowicz's 1992 performance *Red Not Blue [RNB]* at Shoshana Wayne Gallery in Santa Monica but could not make the event and have regretted it ever since. I missed a moment that marked a crucial transition point between the eras of feminist and contemporary art and performance practices. *RNB* represented a new feminist approach of parodying or skewering the privileging of male genius that is built into art value systems through a wily fury tempered by humor. It was also one of the earliest examples of a new approach in contemporary art: appropriation and negotiating art history's pasts.[1]

RNB is tied together by "not," but this "not" is not oppositional or fully negative: as a feminist work typical of its time, it was *not* invested in the same critiques or separatist strategies of earlier feminist art from the 1970s and 1980s. At the same time, it was *not* rejecting feminism or leaving it behind (fulfilling the dubious definition of "postfeminism," a common term by the mid-1990s). *RNB* was, rather, embracing feminism through a kind of mocking, exuberant rage. Like other younger (and mostly white, middle-class) feminist artists who emerged in North America and the United Kingdom around 1990—such as Maureen Connor, Tracey Emin, Nicole Eisenman, Sarah Lucas, Sue Williams, and Millie Wilson—Lachowicz was well aware of the inequities and oppression that continued to face women both in the art world and in society in general. This period was itself an interim for feminist practice: it was *not* 1970s feminist; it did *not* fully adopt 1980s appropriation art strategies; and yet it was *not*, as noted, postfeminist, although some argued otherwise (it was only fully feminist if by this we mean that it focused primarily on addressing gender and sexuality as structures that defined how art and its markets functioned). As Lachowicz's early 1990s work exemplifies, a path had to be forged that tapped into the (still unfortunately salient) rage of earlier feminisms but in relation to new forms of institutional oppression and exclusion that continued to sideline and marginalize women artists.[2]

1 *RNB* was so ahead of its time in this latter sense that the term for such work, *reenactment*, did not come into common usage until more than a decade later, at which point a spate of exhibitions and publications, such as *Experience Memory Re-Enactment* (a 2005 show with accompanying catalogue at the Piet Zwart Institute in Rotterdam), explored at great length the new relationship to history represented by a theoretical and artistic "reworking" of past events, performances, and objects in performance and art histories. For an extensive timeline of reenactments, see Amelia Jones, "Timeline of Ideas," *Perform Repeat Record: Live Art in History*, ed. Amelia Jones and Adrian Heathfield (Bristol: Intellect Press, 2012), 425–34.

2 In a sense I am recuperating Lachowicz's early 1990s art against the grain of the tendency to trivialize this kind of work as "postfeminist" or "bad girls" art. I have written two articles critiquing this tendency: "Feminism, Incorporated: Reading 'Postfeminism' in an Anti-feminist Age," *Afterimage* (Rochester, NY), v. 20, n. 5 (December 1992); and "1970/2007: The Legacy of feminist Art," *Gender Battle* (Santiago de Compostela, Spain: Contemporary Art Centre of Galicia, 2007), reprinted in revised form in *X-Tra* 10.4 (Los Angeles: Spring 2008).

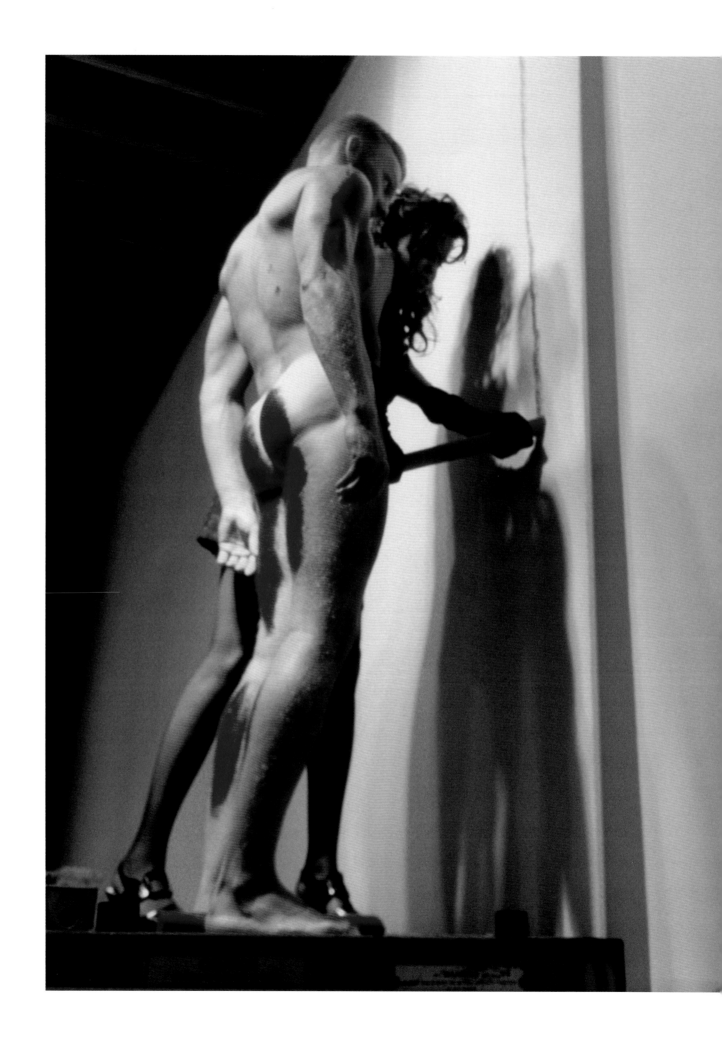

Here I will briefly explore how *RNB*—inasmuch as I can convey its significance through the digital videotape version, stills, resulting images, and textual descriptions I have at my disposal sixteen years later—pivots around this "not" to negotiate in a critical fashion the phallocentrism of art discourse and institutions. *RNB* is inspired by, but is ultimately different in approach and attitude from, earlier critical feminist practices—the exuberance and humor of the work, in fact, could be said to have been made possible by the inroads made by feminist artists, art historians, and critics in the 1970s and 1980s. Lachowicz was typical of this younger generation emerging in the early 1990s in that it was first and foremost outraged by the continuing effects of patriarchal thinking in the art world in particular but was not generally hostile toward historical or contemporary male artists, as had often (understandably) been the case in the 1970s and 1980s (as with Laura Mulvey's excoriation of Alan Jones's misogynistic paintings of women as objects, or Barbara Kruger's angry text/image appropriations that labor to repel the "male gaze").[3] This generation appropriated works and figures from past art histories, like feminists in the 1980s, but humor rather than rage dominates these appropriations, which tended toward refashioning the source material instead of critiquing or overturning it.

RNB can be understood historically as occupying, indeed marking the forefront of, a transitional space of the *not*. The *not* indicates an equivocation: by rejecting negativity, this is a space of humor that looks both backward to earlier oppressions and earlier feminisms, and forward to a future where men and women can work together to defeat a gender binary that is ultimately destructive for everyone.

THE VIDEO RECORDING OF *RNB* shows the following: Lachowicz, in a black cocktail dress and heels, arrives before a formally dressed audience. She enters with two naked men to the strains of live classical cello music played by a woman. The first man sits on a pedestal and courteously holds the artist's evening bag while she ornaments his muscular back with lipstick, drawing the sound-hole shapes of a violin. She smears the second man with melted lipstick after carefully donning a series of surgical gloves. Piled on the floor, they wait like prophylactics for her to make use of them, and they snap officiously every time she puts on a new pair. The gloves provide a more visceral accompaniment to her work with "living paintbrushes" than do the genteel, swooning sounds of the cello.[4] After wiping the second man's torso, buttocks, and penis with the viscous red gloss, Lachowicz proceeds to whisper in his ear (presumably instructions rather than pillow talk) and to guide his pneumatically muscular body onto large sheets of paper or canvas, which then take on red imprints of his V-shaped torso.

Lachowicz's performance directly appropriates and restages the work of French nouveau réaliste artist Yves Klein and his Italian follower Piero Manzoni (Klein's performative *anthropometries* from 1960 to '62 and Manzoni's signing of a woman's body as a "living sculpture" in 1961.) *RNB*'s resulting documentary images and video footage echo the vestiges of these earlier works—for example, the numerous photographs and textual descriptions of Klein's *anthropometry* performances and the resulting body-print pictures he marketed as conventional artworks.

Lachowicz's male body-prints, traces of her gender-reversed reenactment of Klein's stamping of women's bodies, mimic Klein's *anthropometry* paintings—which are also "documents" of his actions. With the woman's body imprints,

3 See Laura Mulvey, "Fears, Fantasies and the Male Unconscious, or 'You Don't Know What is Happening, Do You Mr. Jones?" (1973), reprinted in her *Visual and Other Pleasures* (Bloomington: Indiana University Press, 1989).

4 Yves Klein supposedly described his women models seemingly contemptuously as "living paint brushes," although I have not found a direct quote from Klein himself.

58

5 Apparently Renoir actually said, "it's with my brush that I make love;" in Albert André, *Renoir* (1919), as cited in *The Yale Book of Quotations*, ed. Fred Schapiro (New Haven: Yale University Press, 2006), 633.

6 See Barry Schwabsky, "Piero Manzoni," *Artforum* 36 (May 1998). Available online at: http://findarticles.com/p/articles/mi_m0268/is_n9_v36/ai_n27533121/; accessed 20 June, 2012.

7 Ibid., Lachowicz's line reminds one also of Robert Rauschenberg and John Cage's jointly made *Automobile Tire Print* of 1953 (a queering of modernism if ever there was one, horizontally and automobilically "drawn" as it is) and of Nam June Paik's *Zen For Head*, 1962, a performative line-making piece interpreting La Monte Young's 1960 Fluxus score of "draw a straight line and follow it." Viewed this way, through the lens of a male-dominated (albeit also in the case of Cage and Rauschenberg queer) history of American art, which telescopes backward into the past, Lachowicz's act takes on a more profound significance.

8 Freud wrote famously that the "female genitals are symbolically represented by all such objects as share their characteristic of enclosing a hollow space which can take something into itself." *Introductory lectures on psycho-analysis*, Part II. Dreams (1916), Lecture X: Symbolism in dreams.

9 The woman in *Le Violon d'Ingres* is Man Ray's lover Kiki de Montparnasse. The claim that Manzoni was not in fact making a gendered "statement" on the part of Barry Schwabsky ("[t]he 1961 photo of Manzoni signing the body of a nude woman as a 'living sculpture' may seem to connect him to the all-too-conventional sexual politics of Klein's *anthropometries* (in fact anyone, with Manzoni's signature and the appropriate certification, could become a living sculpture)" . . . doesn't hold water. While "anyone" could hypothetically become a living sculpture, the fact is Manzoni's piece exists in history via the famous documentary photograph of him signing a woman's body. How the work exists in history—in this case as a photo—is crucial to its effects, whatever supposedly Manzoni "intended." Schwabsky, "Piero Manzoni."

breasts (which, in the case of Klein's works, are always large) often form shapes that look like juicy, globular testicles; Klein's *anthropometries* thus turn the woman's body, at least in some cases, into a phallus. In contrast, Lachowicz's he-man, in some instances makes a vaginal imprint: a rippling, rock-solid triangle of muscle marked by a slightly ridiculous staccato exclamation point at the torso's base—the literal indexical imprint of the man's penis. The mark of the cock both "proves" his manhood and, floating below his steely torso-cum-cunt, signifies his castration.

At the denouement of the performance, Lachowicz and the second ("Yves Klein") man step onto a scissor-lift and are raised to the ceiling, at which point the artist attaches a lipstick tube to the man's penis. When the lift descends, his prosthetic lipstick dick/paintbrush draws on the wall a long vertical line, which ends when they arrive at the floor. Lachowicz, the agent of action, forces the man to enact the infamous quote attributed (mistakenly) to impressionist Pierre-Auguste Renoir: "I paint with my prick."[5] She also clearly references Manzoni's 1959–61 "linee" (lines), an interesting, very early example of body art that also points to the development of conceptual art in the late 1960s. Here Manzoni drew various lengths of line in ink on narrow rolls of paper (the drawings serve to document this bodily act for posterity) and then encased them in cylinders with a label on which is inscribed the length of each line and the date it was made.[6]

Lachowicz's line literalizes the "phallic" authority through which Manzoni playfully established the art value of a simple hand-drawn line: by encasing it in a tube and signing it, he extended Marcel Duchamp's readymade act of legitimizing non-crafted objects as art. Manzoni himself was well aware of the interconnections between phallicism, authority, and the market, as is clear in the documentary photographs from these events and from such comments as "I put the *Linea* [line] in a container so that people can buy the idea of the *Linea*. . . . I sell an idea."[7] Lachowicz's line, made through the literalized act of having a penis sketch a vertical "detumescence" of sorts (is this desublimation in action?), authorizes the woman artist as signatory of the "work of art" (the act as well as the "product" resulting from it). While it is the penis that makes the line, it is the woman artist who directs its action.

Meanwhile, the first ("Manzoni") man has been waiting patiently with Lachowicz's purse in hand (according to Freudian theory, the "genital" sac, like lipstick, is a clearly "feminine" attribute).[8] Lachowicz walks over to sign the seated man's back, rendering him a work of art. Along with referencing Duchamp's readymade signing, with this overt objectifying of the male body as an "instrument" to be played, Lachowicz also appropriates and reworks two iconic images/practices from art history: Man Ray's *Violon d'Ingres* photograph from 1924, which shows the back view of a woman's sensuous torso with sound holes to suggest a violin, and Manzoni's *Living Sculpture* from 1961, the latter documented also by an iconic photograph of Manzoni grinning widely as he signs the woman/violin.[9]

AS SUGGESTED, *RNB* REFERENCED a number of specific elements from the early 1960s works by Klein and Manzoni, turning their parodies of modernism into something else entirely (something *not*). Klein's *anthropometries* were mostly staged in private venues, with Klein smearing the model's bodies with his patented International Klein Blue (IKB) paint and then directing the women to imprint themselves on canvases on the wall. In the most famous

version of the *anthropometries,* however, staged at the Galerie Internationale d'Art Contemporain in 1960, Klein deliberately exaggerated his phallic authority by refusing to "dirty" his hands with paint, directing the models to wipe themselves with the IKB paint (which they do, teasingly, for the camera and audience before launching themselves onto the large sheets of paper on the floor and walls). By choosing this method, Klein, in his words, "could continue to maintain a precise distance from [his] creation and still dominate its execution."[10]

Exaggeratedly highlighting the link between male artistic authority and aesthetic value (which becomes economic value on the art market), this famous version was accompanied by an orchestra playing Klein's "Monotone Symphony" (a single note played for twenty minutes followed by twenty minutes of silence). The formally clad guests, described by one art historian as "not at all the avant-garde crowd" but "mostly gallery patrons—a faded social elite," drank blue cocktails and sat in gilded chairs.[11] In the film clips and now iconic images from this performance (both of which were clearly inspirational to Lachowicz), we see prim bourgeois gallery-goers in tuxes and evening gowns look on disapprovingly as Klein theatrically directs his "living paint brushes" to make art.[12] (In Lachowicz's video documentation, we see Los Angeles's 1990s art "elite," who were in this case mostly younger people struggling to earn a living by making or writing about art.)

As this description of Klein's 1960 *anthropometry* performance makes clear, Lachowicz is appropriating works that already adopt and exaggerate tropes of high modernism, thereby profoundly ironicizing them.[13] Manzoni's *Living Sculpture* adopts and pokes fun at Man Ray's attitude toward women's bodies, enacting in a performative way the participation of the male artist in this objectification. He puts the male body back in the picture, thereby short-circuiting fetishism (which demands the erasure or veiling of the castration-anxious male body at its "origin").[14] Through their excess, Klein's *anthropometries* parody the macho rhetoric and painting strategies of abstract painting, and, in particular, Pollock's "action painting" (as it was known through the paintings but also through the early 1950s photographs and film documenting the process) and de Kooning's "women" series of the 1950s. While Pollock's heterosexual masculinity is confirmed by images and texts attesting to his mucking about in house paint and placing himself heroically in the canvas as an "arena in which to act,"[15] Klein refrains from even touching paint, acting more as a genteel choreographer than as an action painter.

Lachowicz's acts of painting and drawing with male bodies are obviously feminist reversals of the practices and images (paintings, drawings, but also performance documents) of Manzoni and Klein. This reading is not only how they were interpreted in the media at the time but also reading corresponds with a 1970s feminist strategy—developed by artists such as Margaret Harrison, Sylvia Sleigh, and Judith Bernstein—of objectifying the male body to make a critique of the age-old fetishization of women's bodies in Western art.[16] But rather than support the dominant interpretations of Lachowicz's works from this period as simple reversals, I want to argue that the actions and references of Lachowicz's *RNB* are potentially queering—producing a third space against the grain of heteronormative definitions of gender—if viewed within the longer history we now have of contemporary art. While Margaret Harrison's 1971 drawing *He's Only a Bunny Boy* was a dramatic and simple reversal, portraying Hugh Heffner with the body of a

10 Yves Klein, "Truth Becomes Reality" (1961), tr. Howard Beckman, in *Yves Klein 1928-1962 A Retrospective,* exhibition catalogue (Houston: Institute for the Arts, Rice University, 1982), 230.

11 Sidra Stich on the patrons in *Yves Klein,* exhibition catalogue (Ostfildern: Cantz Verlag, 1995), 173.

12 See the short clips of the films at http://video.google.com/videoplay?docid=8859506883702524061&q=Yves+Klein and http://www.ubu.com/film/klein.html.

13 Whether or not Klein "intended" to ironicize them is a complex question beyond the scope of this essay; he was deeply invested in language of transcendence and mythical ideas about art, but at the same time the *anthropometries* and his descriptions of them are so excessively "phallocentric" that we certainly tend to read them as ironic.

14 Fetishism is for Freud all about the male's castration anxiety but of course it is not the male body that takes on the representational chore of being made into a visual image in order to assuage castration anxiety; paradoxically in his heteronormative model it is the woman's body, which was the initial cause of castration anxiety in the first place (because of its purported "lack" of a penis); that must serve as a palliative replacement for the missing phallus by being fetishized continually. See Freud, "Fetishism" (1927), tr. Joan Riviere, *Sexuality and the Psychology of Love* (NY: Macmillan, 1963), 214–29.

15 These are Harold Rosenberg's famous descriptive terms in his 1952 article "American Action Painters," *Art News* 51, n. 8 (December 1952), 22–23, 48–50.

16 Lisa Tickner outlines this as one of four major feminist strategies in the visual arts in her important essay "The Body Politic: Female Sexuality and Women Artists since 1970," *Art History* 1, n. 2 (June 1978), 236–251. As Tickner suggests, the strategy is limited as it keeps the binary structures of fetishism and gender construction in place and, as other feminists—particularly Mary Kelly—have argued elsewhere, fetishism as a structure in Euro-American culture can't simply be reversed. It is structurally weighted to favor masculinity at the cost of the female body.

60

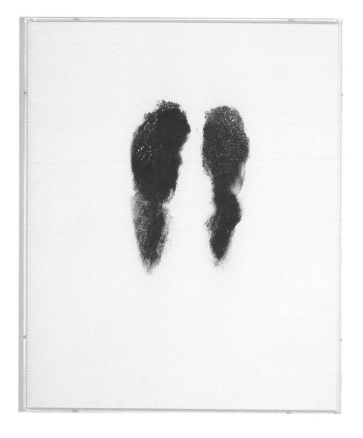

BUTTOCKS, 1992
LIPSTICK ON CANVAS
38¾ X 32½ INCHES

Playboy bunny, Lachowicz becomes the male artist (in a cocktail dress) and gently, but assertively, interacts with her male models.

Even as Lachowicz's practice has always been positioned within a heteronormative, white, middle-class feminist practice (as is true of most feminist art up until very recently), rather than reversing the binary in an obvious or simple way, then, *RNB* perhaps inadvertently courts something other. Lachowicz's painting/drawing on the men's bodies and her elaborate choreographing of their movements turn hypermasculine male bodies not into "female" ones but into queer bodies: still hypermasculine in appearance, they are porous and subordinate to her suggestion. If anything, they read as masochistic in relation to her dominatrix (although, in demeanor and body movement, they are not at all cowering or subservient). At no point do we feel any contempt, anger, or rudeness coming from Lachowicz's end nor do the men take a subordinate attitude (though at various points the "Yves Klein" man covers his genitalia modestly). In contrast to the righteous and critically effective reviling of masculinity demanded by some critical models in 1970s and 1980s feminism (such as Mulvey and Kruger, as noted above), this kind of masculinity is allowed to unfold in a conflicted field of action. This is masculinity otherwise (or *not* masculinity?).

WHAT DID IT MEAN FOR Lachowicz to parody Klein's and Manzoni's already parodied versions of modernism in the early 1990s? By this time, Lachowicz had produced a whole cluster of works that were seen as definitive examples of a new feminist art that reflected a changed relationship to past art histories. In the words of *New York Times* critic Roberta Smith, one of the most influential figures on the then New York–dominated art scene in the early 1990s, Lachowicz exemplified the "new feminist appropriationists."[17] Along with other works appropriating and reworking minimalist and readymade works, *RNB* clearly demonstrated this new feminist appropriationist attitude toward art history's past—adopting critically, but with humor, modes of practice identified with two male artists who had already brought to an exaggerated extreme the attributes of masculine artistic creativity. Unlike the tendency in 1980s appropriation to aim at refusing or destroying past cultural structures (as in Barbara Kruger's work), the new feminist appropriationist goal was to interrogate, parody, and exaggerate these models, tropes, and themes being appropriated—not to overthrow them but to adopt some of the power they conferred, embracing and reworking useful aspects of them while also acknowledging their history in relation to women's oppression, objectification, and exclusion.

17 Roberta Smith, "Women Artists Engage the 'Enemy',"
New York Times (August 16, 1992), section 2, p. 1.

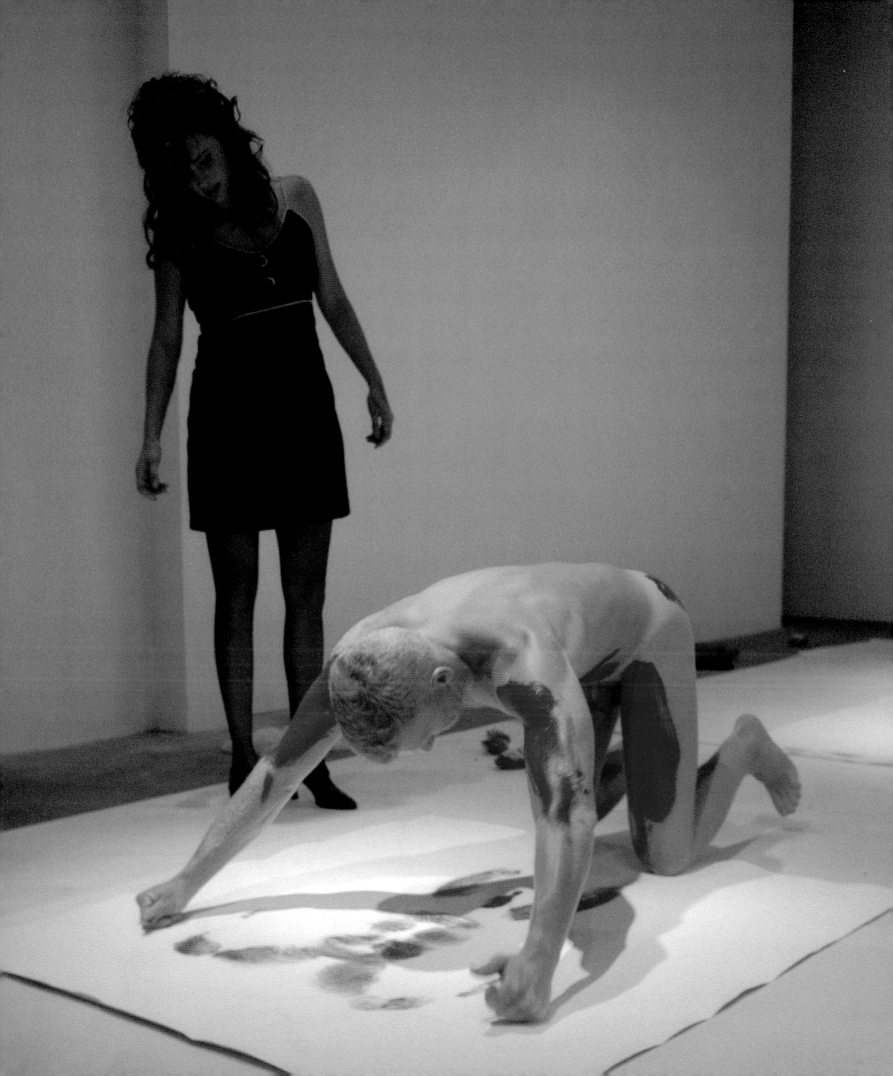

ORANGE COUNTY MUSEUM OF ART, NEWPORT BEACH, CA
INSTALLATION VIEW
1992

What made Lachowicz's *RNB* original at the time was that it reenacted performative practices from an earlier period rather than simply reusing images or materials in static form, as in the work of many other younger feminist artists and, in fact, in much of Lachowicz's own object-based work at the time. Lachowicz's objects were based on works appropriated from past, masculine examples in the history of art but recast in lipstick. They included *Red David* (a male torso, taken presumably from Michelangelo's *David* but also reminiscent of the classical feminine ideal of the *Venus de Milo* torso); the three-part *Lipstick Urinals*, which turned Duchamp's 1917 *Fountain* right-side up but continued to refuse its utility; or her three refabricated versions of minimalist classics, *Homage to Carl Andre*, a lipstick adaptation of Andre's 1969 floor piece, *Magnesium and Zinc*; *Sarah*, a modestly sized version of Richard Serra's gigantic 1969 *One Ton Prop (House of Cards)*; and the tiny *Lipstick Cube*, which miniaturizes Tony Smith's famous six-foot-high cubic steel sculpture, *Die* (1962).

In these works, in addition to the critical intervention afforded by the strategy of appropriation itself, Lachowicz shifted the scale and material to "feminize" the massive and aggressive minimalist works as well as to extend a signature strategy from 1970s feminism of injecting content into supposedly completely abstract modernist forms. This latter strategy functioned to expose the way in which high modernism, no matter how apparently abstract, was always already invested, biased, and contingent on masculinist belief systems, themselves intertwined with classism, racism, and other forms of exclusionary thought. For example, Judy Chicago had taken this strategy to a brilliant limit in her early to mid-1970s central-core images, some of which—such as the 1974 *Peeling Back,* a flayed, abstracted central-core image with extended textual descriptions of Chicago's mistreatment at the hands of a patriarchal art world—were so explicitly filled with content that they assaulted viewers while simultaneously seducing them with the lush forms of the "abstracted" female body.

Lachowicz's lipstick objects take this method further, deploying a material that insistently injects content to remake masculinist minimalist objects, turning cubes and slabs effectively into giant versions of women's cosmetics (and turning women's cosmetics into formalist artworks).[18] Lachowicz, like Chicago before her, thus deliberately refused the high modernist insistence (on the part of formalists such as Clive Bell and Clement Greenberg) that modernist artworks eschew the literary or narrative—a claim that had clearly served to exclude work by women and people of color on the basis of vague notions of "quality" while actually veiling sexist and racist value judgments based on nothing more than assumptions about these artists' capacity to make "great" art.

Lachowicz's use of lipstick indicates that the abstraction is always already narrative; it always already has content that, in turn, indicates ideological biases and effects. Just as Richard Serra's choice of Cor-ten steel and his tendency to construct very large-scale objects that tower over the viewer bring with them connotations of the masculine and the industrial and, as feminist art historian Anna Chave has famously claimed, are thus informed by and reinforce a "rhetoric of power,"[19] so Lachowicz's deployment of lipstick and a shift in scale to remake such works brings new, and in the context of the time, "feminist" connotations to the same basic shapes (lipstick makes us think of feminine beauty, eroticism, menstrual blood, etc.). The very recognition of the fact that, say in the case of *Lipstick Cube*, the box

18 In some ways, the early 1970s practices, however, were just as radical, if not more so; Chicago's brilliance in her early work was to make use of "masculine" production techniques, such as auto-body painting, to produce abstracted central core images and objects that were thus symbolically gendered as simultaneously masculine and feminine.

19 Anna C. Chave, "Minimalism and the Rhetoric of Power," *Arts Magazine* 64 (January 1990), pages 116–38.

shape is forged of congealed lipstick—and that our experience of it is completely different given its sensuous surface and small scale—makes us aware, if we have a reference system that includes the original Tony Smith piece, of a range of gendered meanings attached to the massively scaled metal cube he devised in the early 1960s.[20]

Lachowicz paid homage to but also unhinged these hidden aspects of modernism, joining generations of artists who had been chipping away at its pretensions—particularly in its dominant forms as congealed in art criticism and among conservative curators in major institutions. It is no surprise, then, that the late Kirk Varnadoe, curator at MOMA in New York, would be patronizing and dismissive when addressing the relationship between Lachowicz's appropriations (in this case her work *Sarah*) and the originals:

[In her reworkings of minimalist objects Lachowicz poses] an accusation that the seeming neutrality of Serra is again intensely masculine and delimited, that the abstraction that Serra claims is only coded representation, that abstraction is in some sense impossible. So says this jibe. And yet is this in fact the end of abstraction? The arrival of something like the Lachowicz? Is it more knowing than the Serra? Is it wiser? Or is this one-liner only a natural part of a recurrent life cycle, the cycling back and forth between the pursuit of the neutral and the abstract and the recursion of social meaning and metaphor? If Lachowicz makes a mistake about Serra, it is the classic mistake of essentialism, I think—essentialism and meaning. The point about these four plates of steel, put together in a balanced cube, is not what these things are, what this thing is, but what you can do with those things, or this thing. What can be done with steel and balance?[21]

Varnadoe's need to sneer at Lachowicz's project is distressing from a feminist point of view. The stakes he has in relegating her project to insignificance as a one-liner "jibe" that essentializes minimalism by taking it too literally is a perfect example of exactly the kind of "self-evident" model of formalism that feminists have struggled to expose and overthrow since the late 1960s. Such a model adopts a language of authority to dismiss any critiques or interventions as mistakenly introducing content where there already exists perfect meaning—meaning that seems always to escape any specificities that would point to its investments in machismo, exclusionary thinking, or the privileging of male artists over female.

But Varnadoe's response to Lachowicz is actually rather bracing if we view it as evidence that this new feminist appropriationist work was doing good. He clearly felt threatened by the way in which Lachowicz's project has exposed the contingency of minimalism's supposedly completely neutral forms, which are, he argued, about only the properties of steel and balance. For, if Serra's forms were inherently referencing a closed meaning system of materials and form, then why would a younger artist's reworking of them in lipstick be of any concern to the formalist critic? Lachowicz's reworkings provide "narrative" meaning (i.e., connections between forms, materials, and broader social structures of signification), where formalist critics want only "abstract"—and thus supposedly neutral—aesthetic value, which then confirms their judgment of the work as superior. After all, Varnadoe's validation of the superiority of Serra's

20 I discuss the particular possibilities of gendered and raced interpretation in relation to Smith's wonderful piece in my essay "Art History/Art Criticism: Performing Meaning," *Performing the Body/Performing the Text*, ed. Amelia Jones and Andrew Stephenson (London and New York: Routledge Press, 1999), 39–55.

21 Varnadoe, in *Pictures of Nothing: Abstract Art Since Pollock* (Princeton, New Jersey: Princeton University Press, 2003), 260.

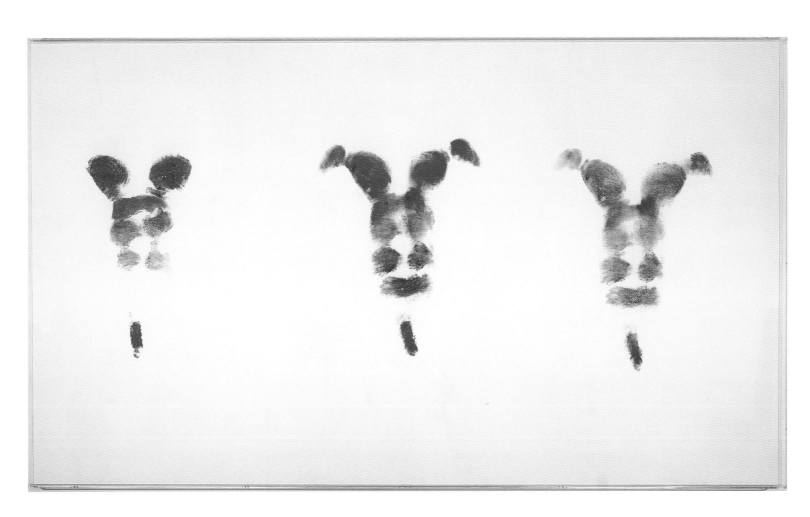

THREE TORSOS WITH PENES, 1992
LIPSTICK ON CANVAS
57 X 99 INCHES
PRIVATE COLLECTION, NEW YORK

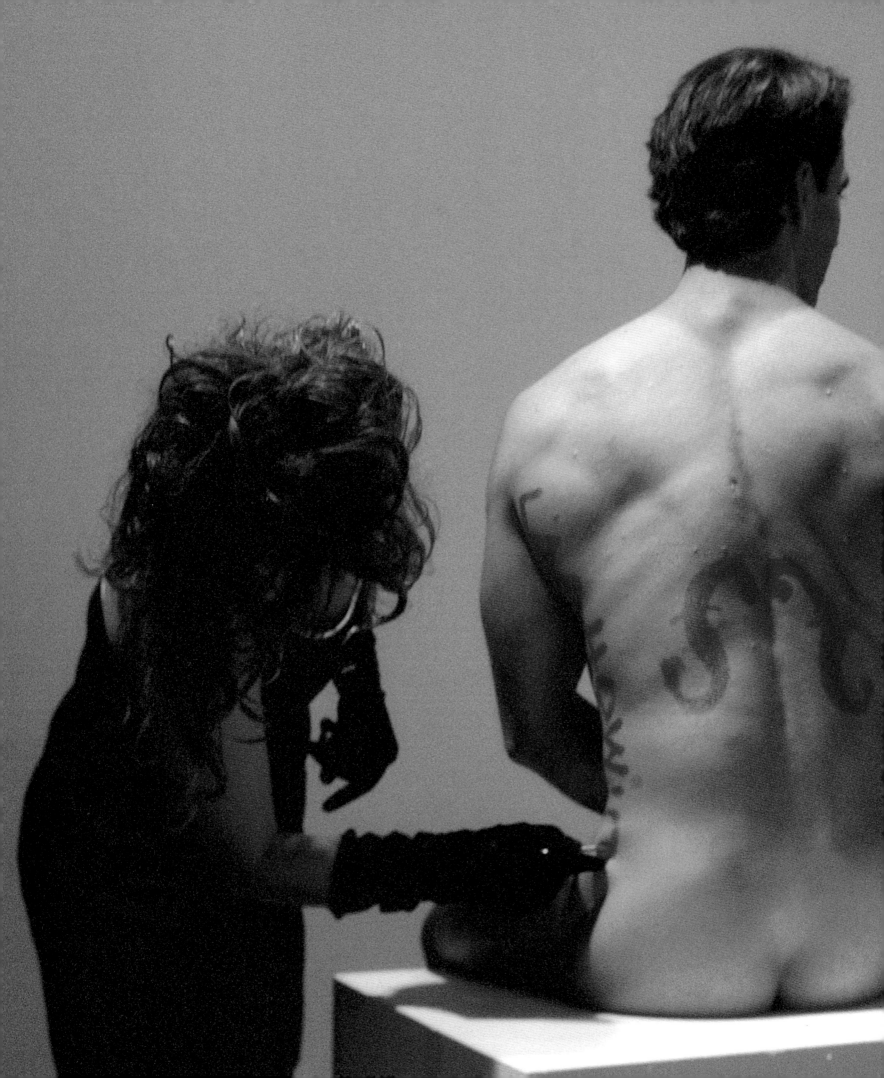

engineering acumen reciprocally points backward to confirm his own art critical genius in identifying the work's importance in opposition to Lachowicz's supposedly essentializing, narrative, and unsophisticated "jibes."

RNB draws on a different art history, of course, one that (as noted) already ironicized the models Varnadoe still wanted to cling to in the early 2000s—that of the nouveaux réalistes, with their ironic and performative relationship to male artistic authority. The performance also, of course, draws on feminist strategies of appropriation and reversal and reworks them. While in some ways obvious, Lachowicz's reenactment of Klein's and Manzoni's practices exemplifies a fascinating and crucial moment in the history of contemporary art: a shift from earlier modes of critique and appropriation to a more nuanced approach to the past, particularly as understood through phallocentric narratives of Euro-American art history. The earlier modes, particularly within feminist art theory and practice, were vital to the development of a more nuanced field of inquiry in which artists such as Lachowicz could intervene and rethink gender relations and systems for determining value in the art world—including even feminist value systems, and the tendency up to that point for artworld feminisms to be dominated by white, heteronormative, middle-class assumptions. As noted, these interventions were never simplistically binary (although Lachowicz's appropriations have been viewed as such by critics like Varnadoe). Rather, at their best—as with *RNB*—they queer binary structures of gender in a feminist way.

While apparently "obvious," if returned to the complexity of its historical moment (and I haven't even touched here on what it meant to do such work in Los Angeles, at the margins of the then New York–centered US art world), Lachowicz's *RNB* in this way hovers at the threshold of change. It points backward in the ways noted. But it also indicates a way forward, beyond the binaries which feminism was committed to critiquing but which it also (by critiquing them) obsessively reproduced. This is the "not" that *RNB* opens for us, looking back twenty years later from a totally different moment in the history of contemporary art and feminism.|

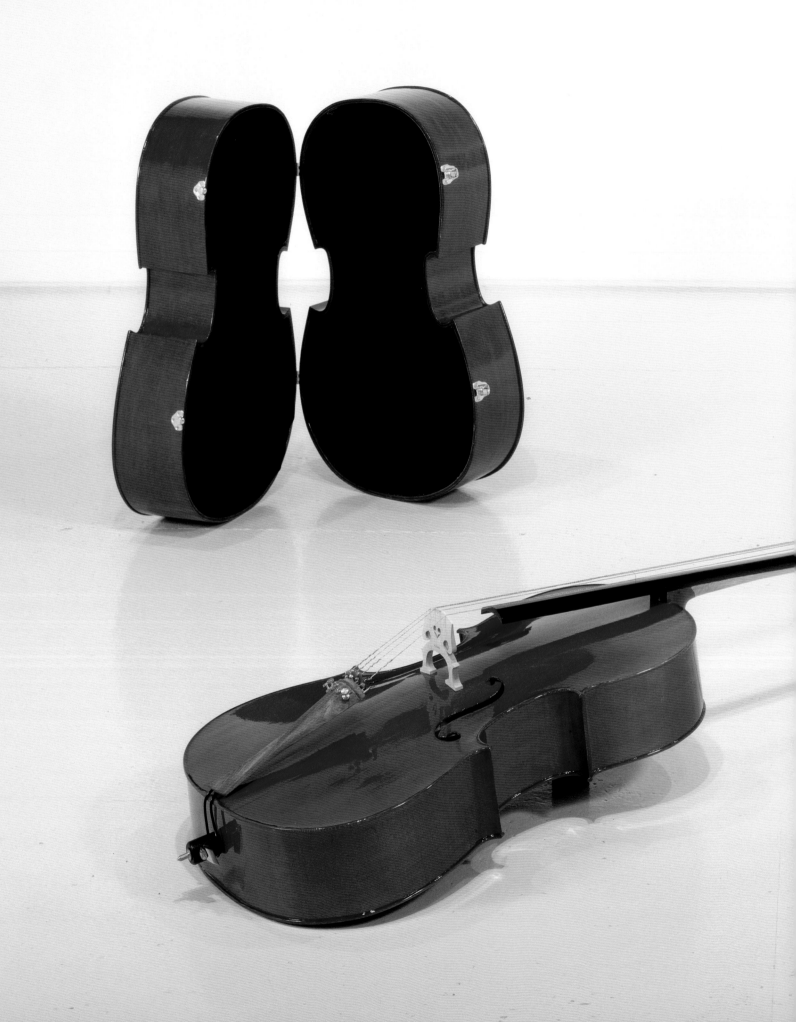

BRAVADO, 1993
WOOD, ENAMEL
CELLO: 134 X 18 X 5 INCHES
CASE: 31½ X 18½ X 12¾ INCHES
PETER NORTON

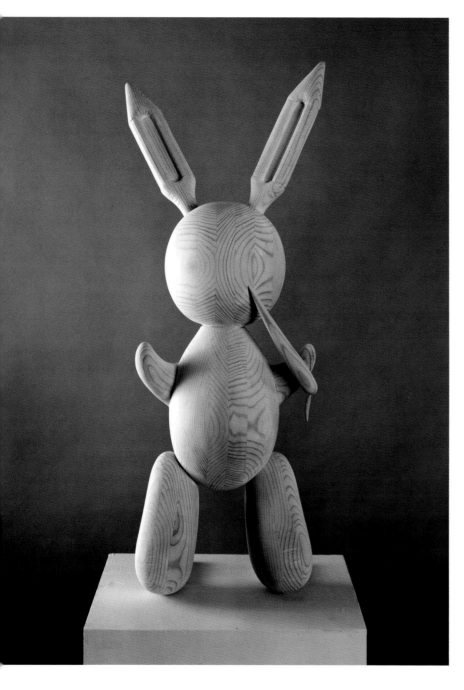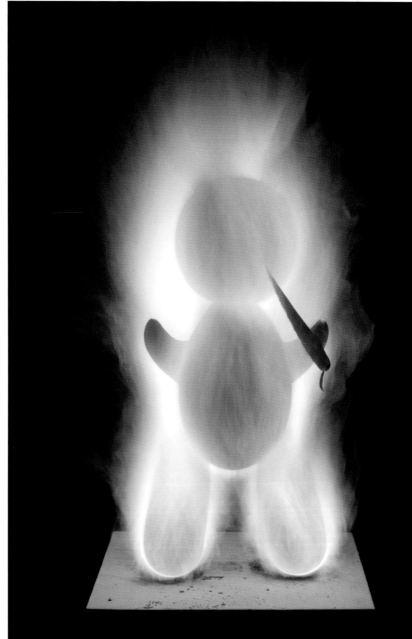

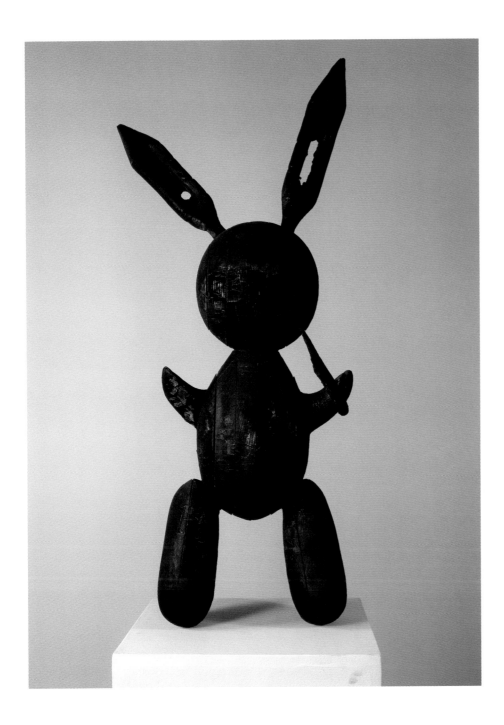

BURNT BUNNIES, 1993
WOOD, 2 PHOTOGRAPHS
FIGURE: 43 X 14 X 9 INCHES; PHOTOGRAPHS:
19¾ X 16 INCHES EACH
EDITION: 3
THE MUSEUM OF CONTEMPORARY ART, LOS ANGELES
GIFT OF THE PETER NORTON FAMILY FOUNDATION

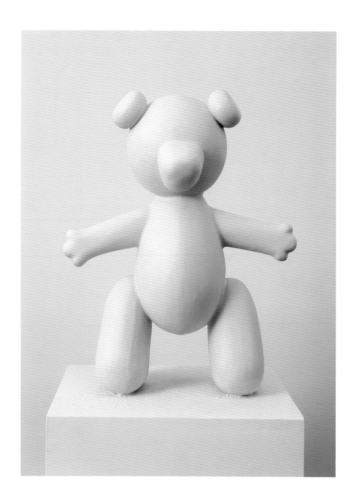

PSEUDO-COSMETIC CARNIVORE, 1995
PORCELAIN, PORCELAIN POWDER
31 X 26 X 11 INCHES
EDITION: 2
SCHWEBER COLLECTION, NEW YORK

FAWBUSH GALLERY, NEW YORK, NY
INSTALLATION VIEW
1995

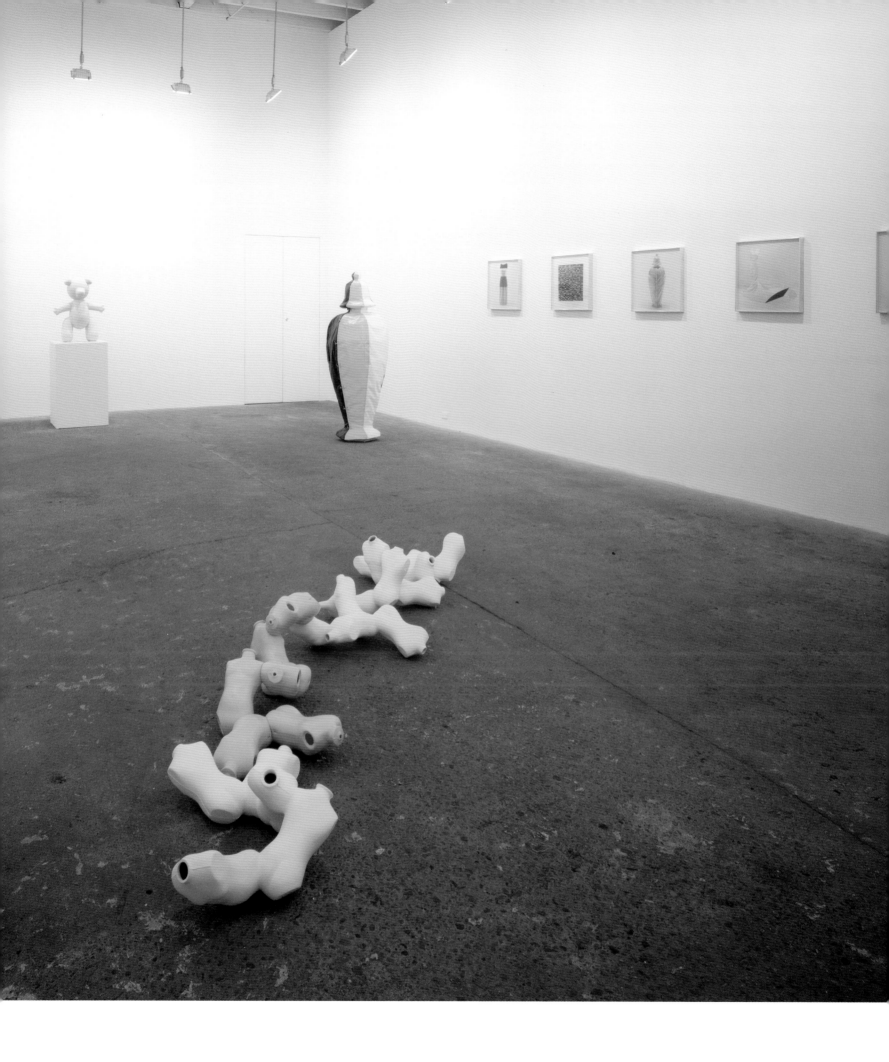

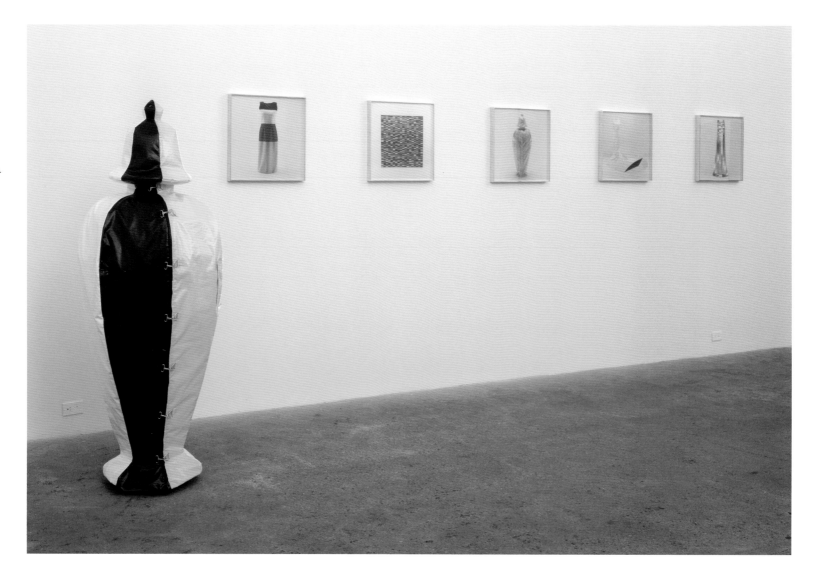

ORIGINALS, 1995
5 PHOTOGRAPHS & PERFECT RAINCOAT (PRODUCED BY THE FABRIC WORKSHOP):
SCREEN TEX VINYL, FABRIC, WOODEN ARMATURE
RAINCOAT: 72 INCHES TALL
PHOTOGRAPHS: 20 X 20 INCHES EACH
1. REPLICA OF ELLSWORTH KELLY DRESS CONSTRUCTED BY NATHALIE SEAVER
2. EYESHADOW MODEL FOR DRESS #5
3. PERFECT RAINCOAT
4. BLUE CURVE
5. DRESS #5 CLEOPATRA MODELED AFTER EYESHADOW
PRIVATE COLLECTION, NEW YORK

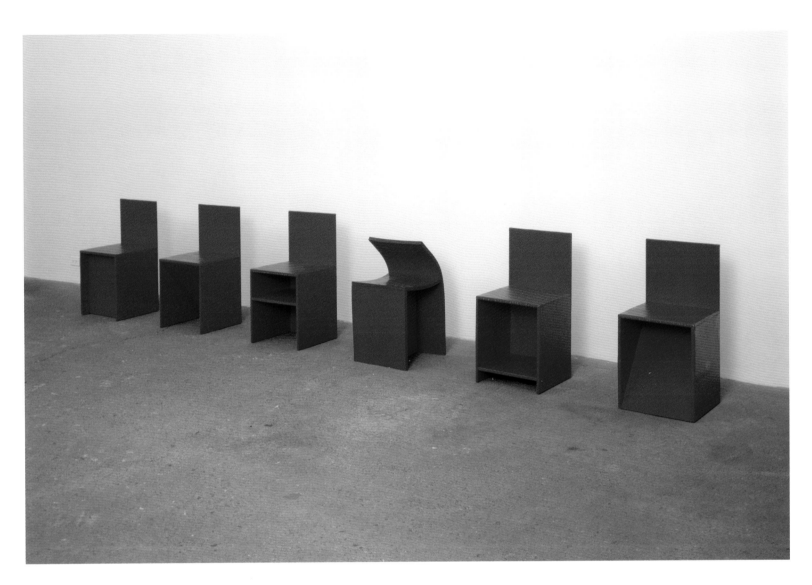

ANAGRAM, 1995
DONALD JUDD CHAIRS, LIPSTICK, WOOD, RUBBER
6 ELEMENTS: 30¾ X 15¾ X 17¾ INCHES EACH
ROSELLA AND PHILIP ROLLA
ROLLA COLLECTION, SWITZERLAND

WAS IST LOØS, A REALIZATION OF ADOLF LOOS'
HOUSE FOR JOSEPHINE BAKER, 1995
TENT, 2 PHOTOGRAPHS
TENT: 30 X 45 X 118 INCHES
PHOTOGRAPHS: 24½ X 17 INCHES EACH

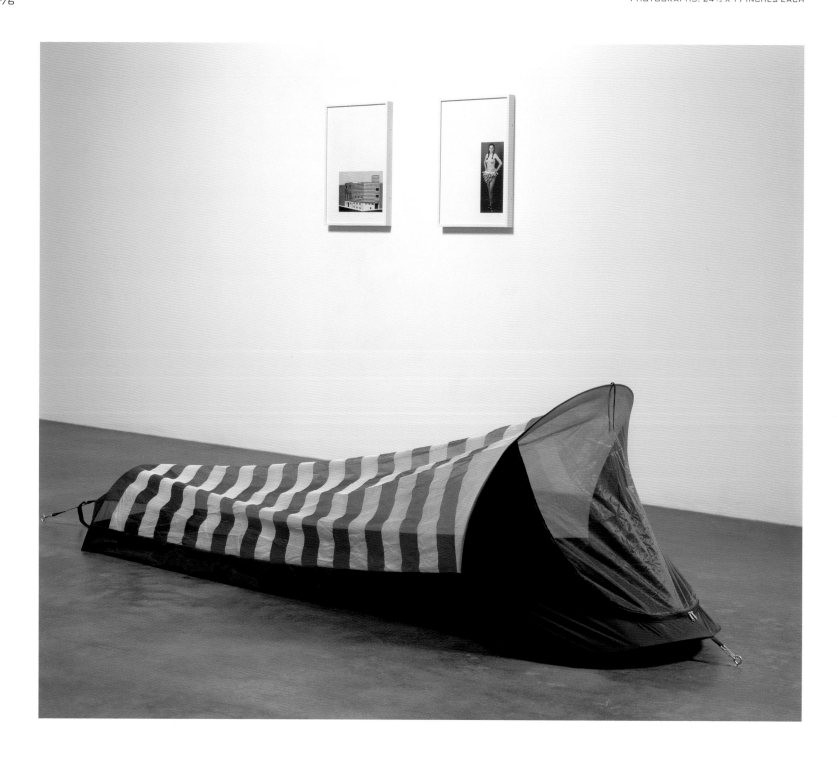

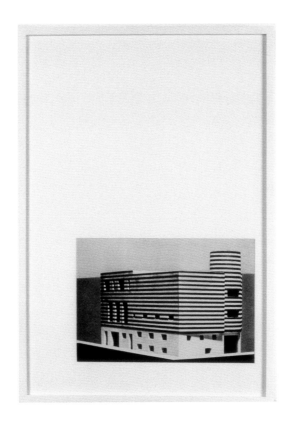

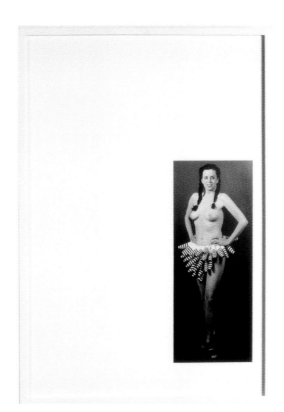

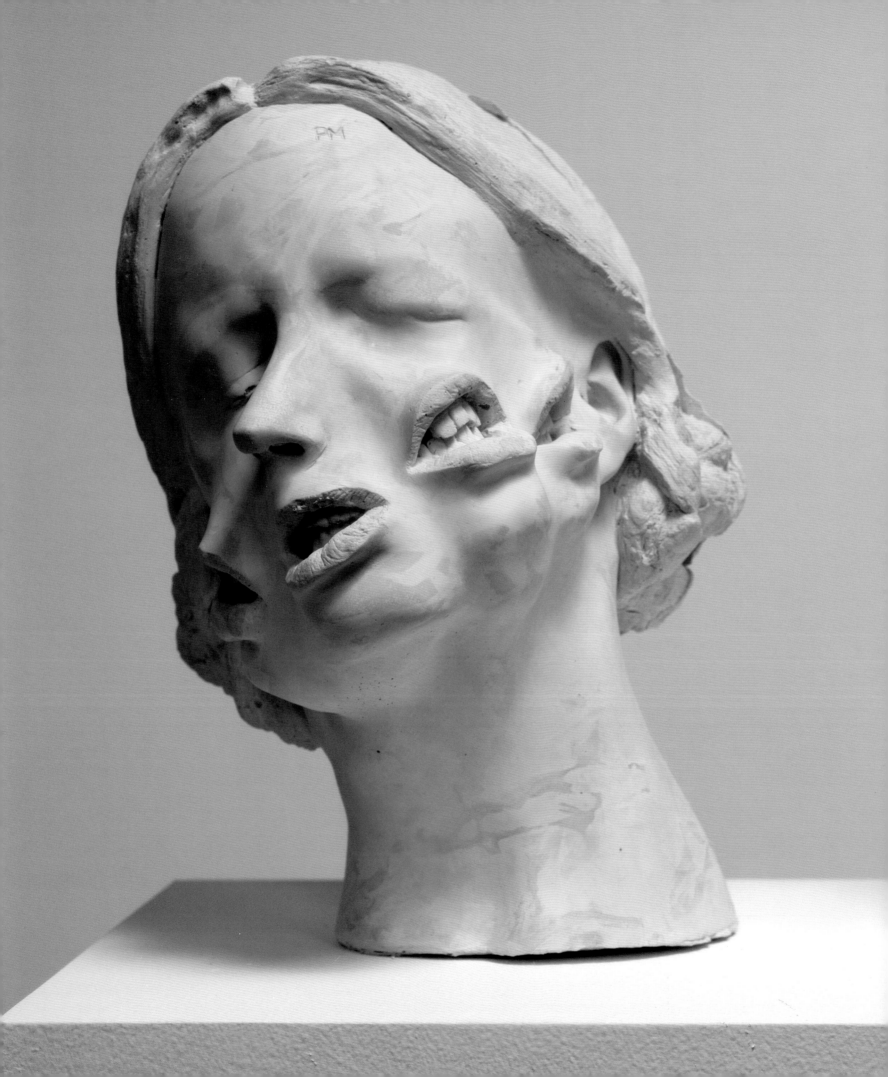

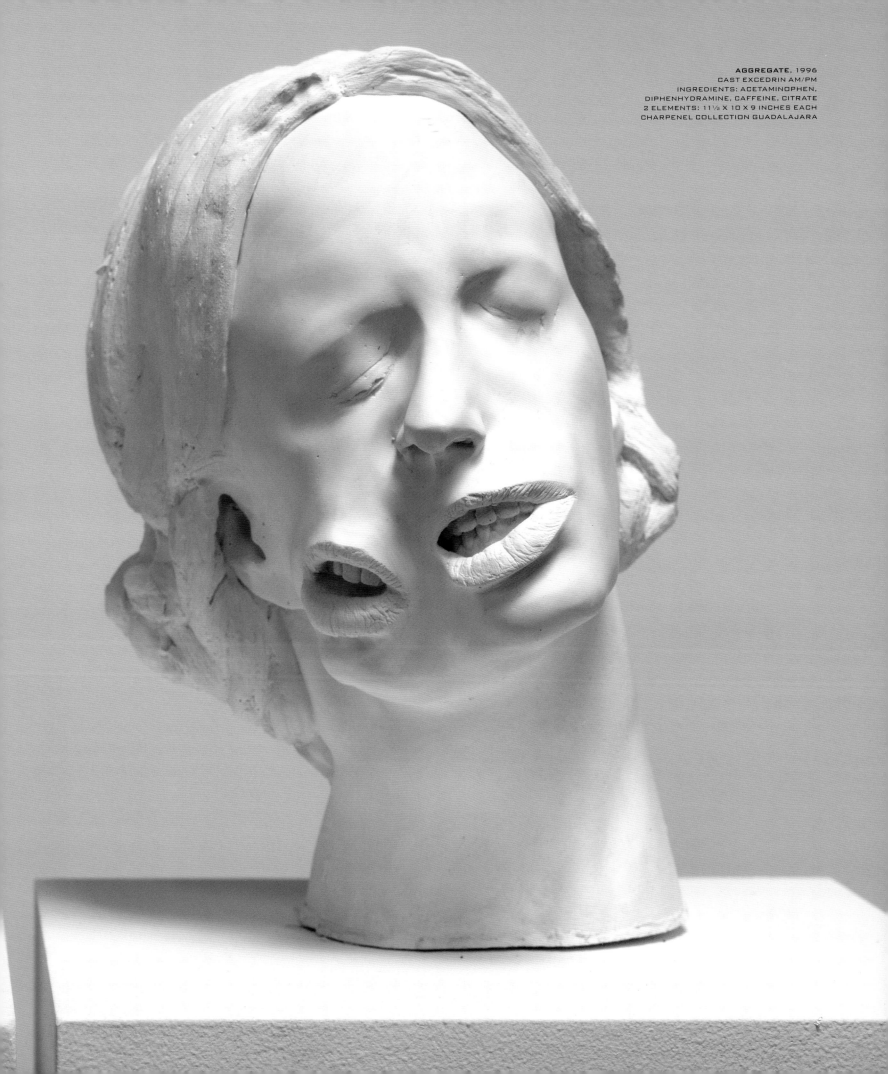

AGGREGATE, 1996
CAST EXCEDRIN AM/PM
INGREDIENTS: ACETAMINOPHEN,
DIPHENHYDRAMINE, CAFFEINE, CITRATE
2 ELEMENTS: 11½ X 10 X 9 INCHES EACH
CHARPENEL COLLECTION GUADALAJARA

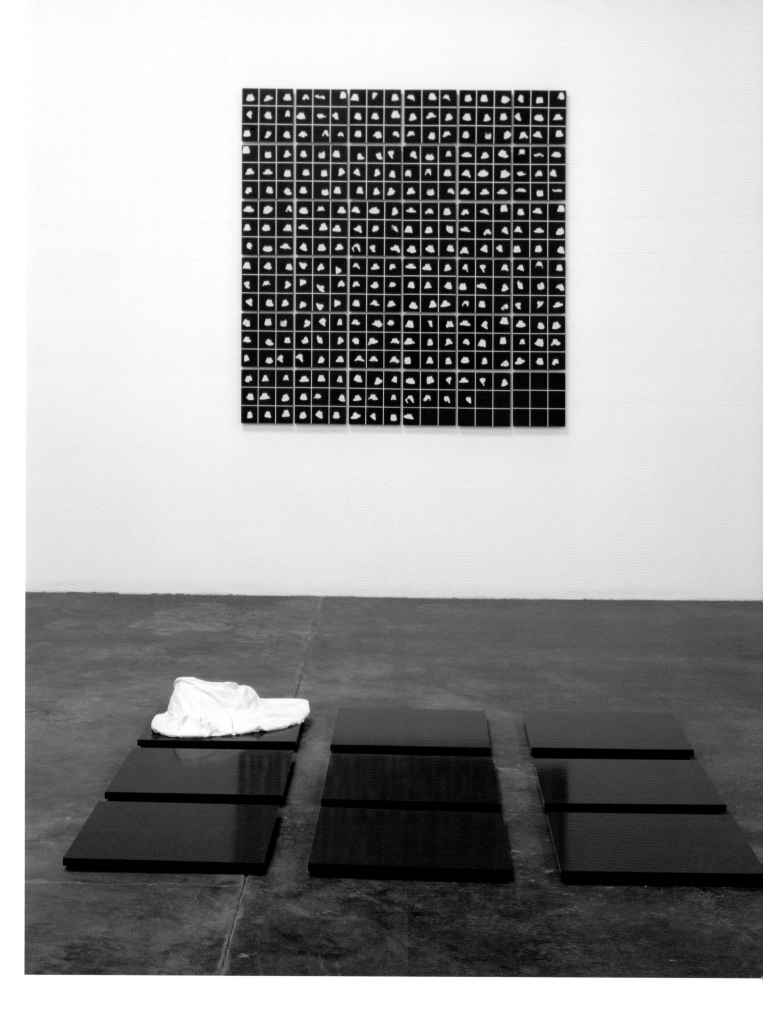

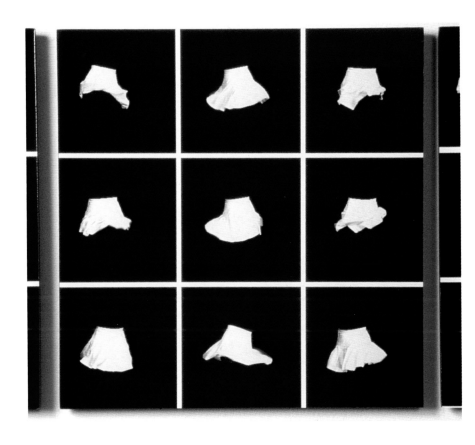

FORM INTO UNIFORM INTO FORMLESSNESS, 1996
LIGHTJET VIDEO CAPTURE ON PLEXIGLAS, ENAMEL ON ALUMINUM, PLASTER, FABRIC
62 X 62 X 1 INCH; 7½ X 69½ X 69½ INCHES
MATTHEW & IRIS STRAUSS COLLECTION, RANCHO SANTA FE, CA

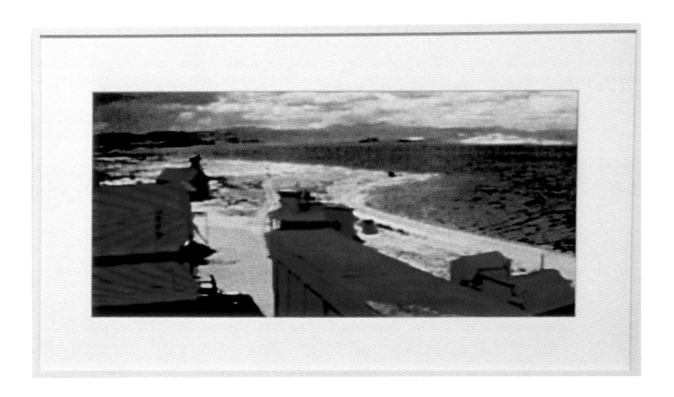

COMPOUND, 1996
IRIS PRINTS, VIDEO CAPTURES
4 ELEMENTS: 16¼ X 29½ INCHES EACH

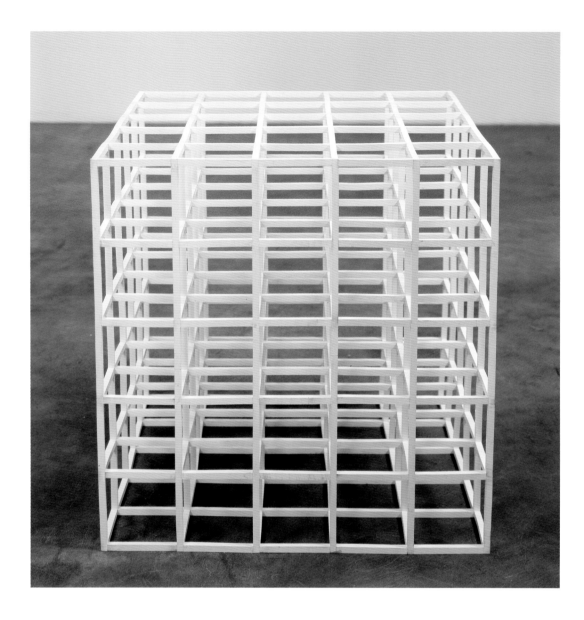

FLEXIBLE—OPEN CUBE, 1996
RUBBER
30¾ X 30¾ X 30½ INCHES
PETER NORTON

COLLAPSED—OPEN CUBE, 1996
RUBBER
12 X 50½ X 42 INCHES
PETER NORTON

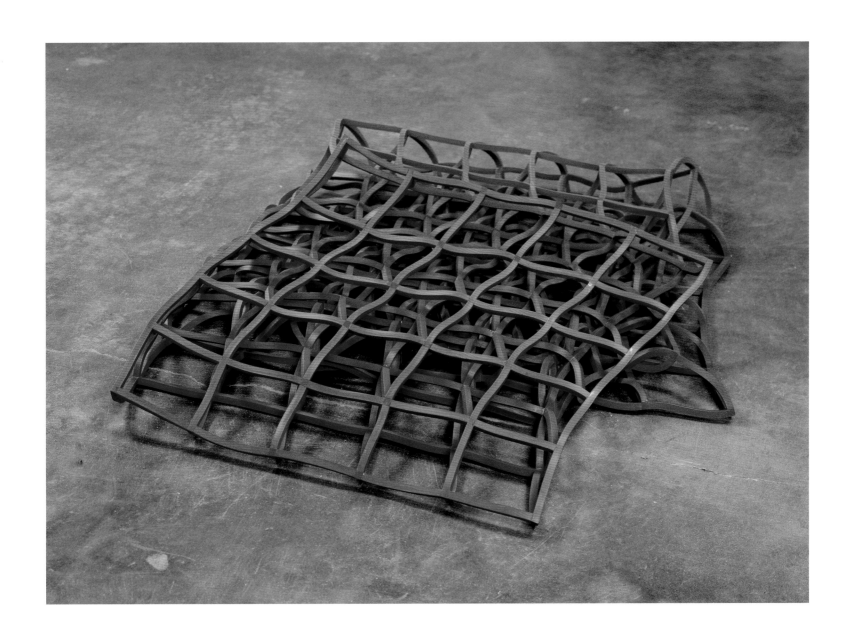

TEMPLE OF APOLLO, 1998
EYESHADOW, ALUMINUM, BAKED ENAMEL, STEEL
48⁷/₈ X 78³/₄ X 1¹/₄ INCHES

BLUE GREEN TRANSFORMATION, 1998
EYESHADOW, ALUMINUM
58½ X 47¾ X 1¼ INCHES
SUNAMERICA COLLECTION

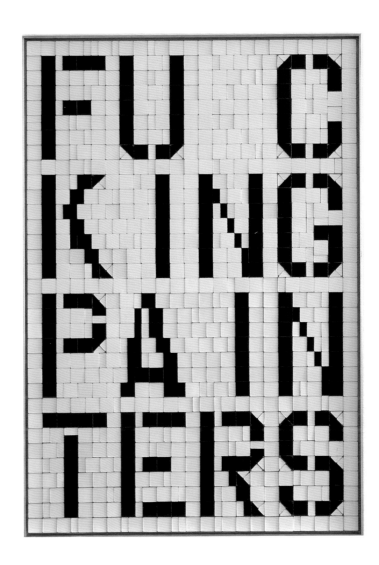

FUCKING PAINTERS, 2000
EYESHADOW, ALUMINUM
49¾ X 35 INCHES
PRIVATE COLLECTION

ONE TO ONE, 1998–99
EYESHADOW, ALUMINUM
113⁴/₅ X 44¾ INCHES
ROSELLA AND PHILIP ROLLA
ROLLA COLLECTION, SWITZERLAND

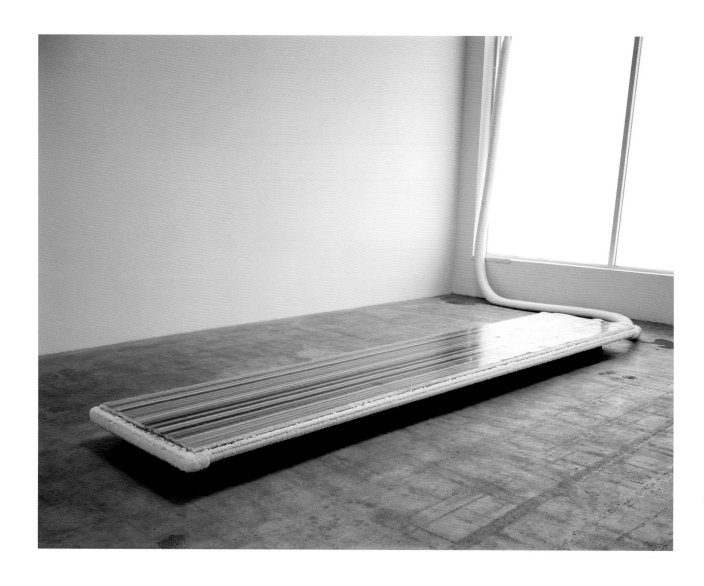

CYRO-FIELD (FROZEN WATERCOLOR), 2001
WATER, PIGMENT, REFRIGERATION PANEL
32 X 143 X 6 INCHES

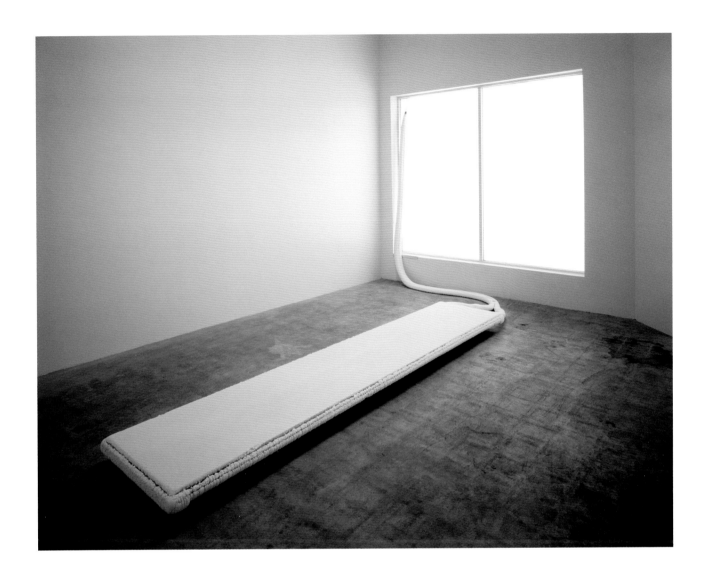

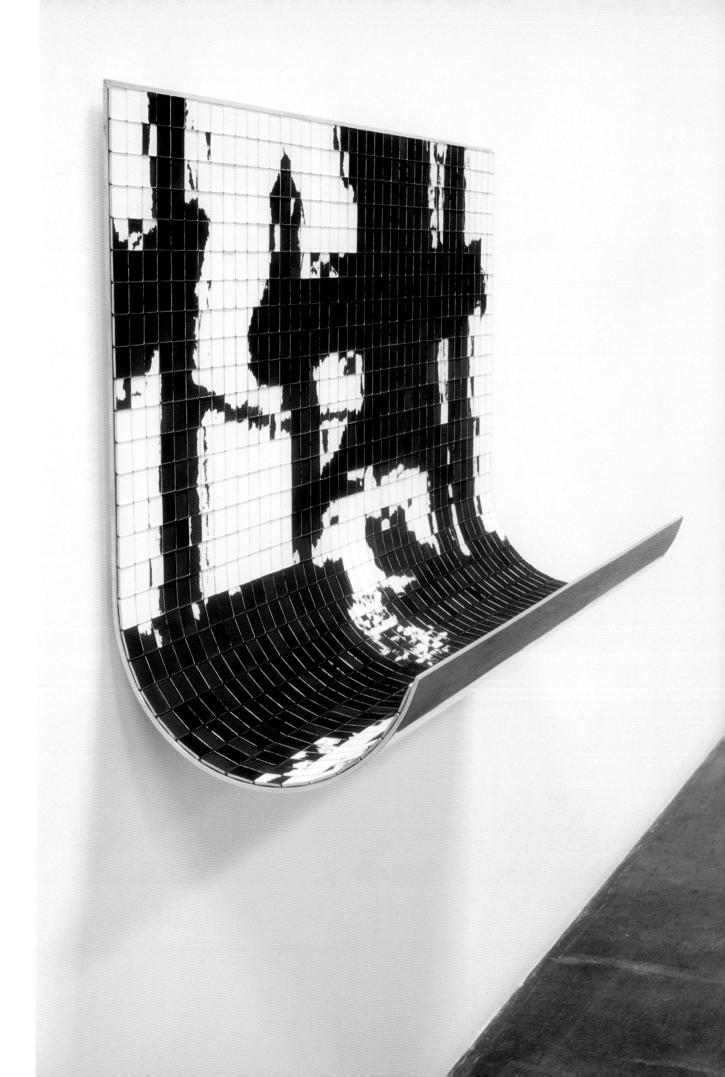

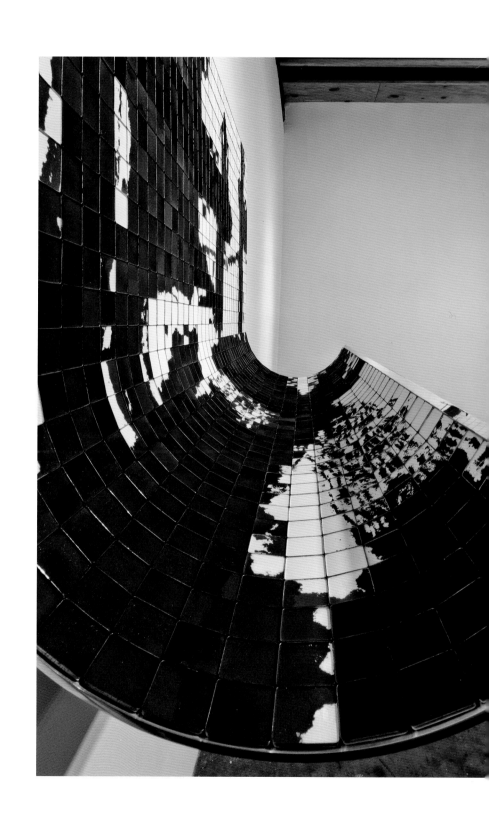

KLINE CURVE, 2005
EYESHADOW, PIGMENT, ALUMINUM
32 X 59 X 15½ INCHES

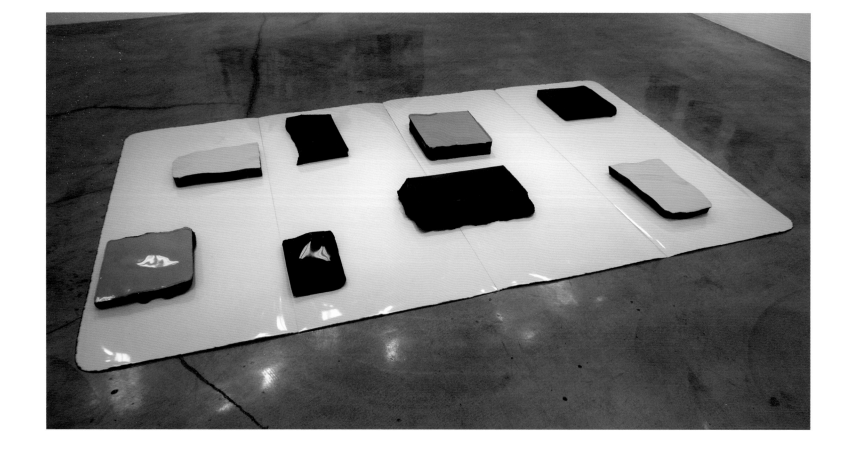

CARBON FUSION, 2012
MIXED PLASTICS PLEXIGLASS, VINYL, STYRENE, LAMINATE
6 INCHES X 16 FEET X 10 FEET
(1999 INSTALLATION "SOLID SURFACE" COLLABORATION WITH RANDY JACOBS)

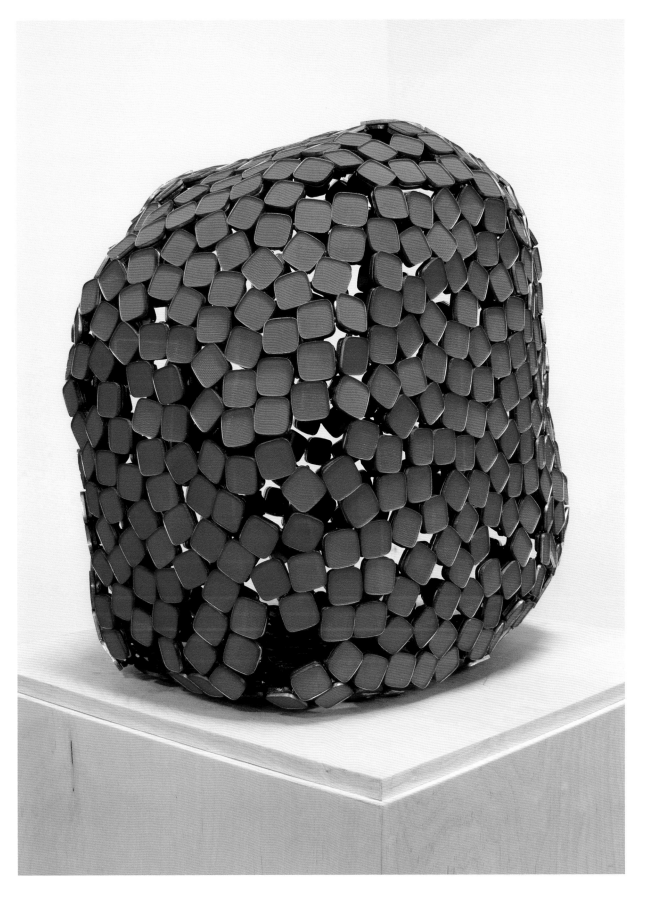

3D STELLA, 2005
EYESHADOW, ALUMINUM
22 X 15 X 21 INCHES
PRIVATE COLLECTION, NEW YORK

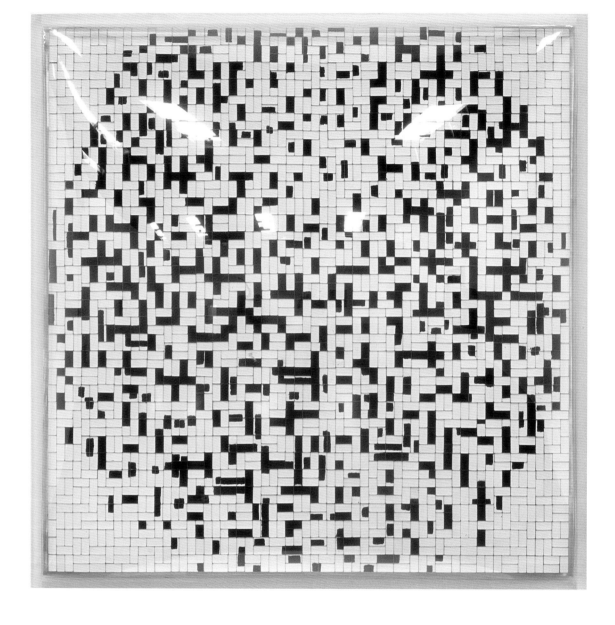

MONDRIAN BULGE, 2005
EYESHADOW, PIGMENT, 3D PLEXI COVER
50½ X 50¼ X 14 INCHES
LILLY AND BRUCE KARATZ COLLECTION

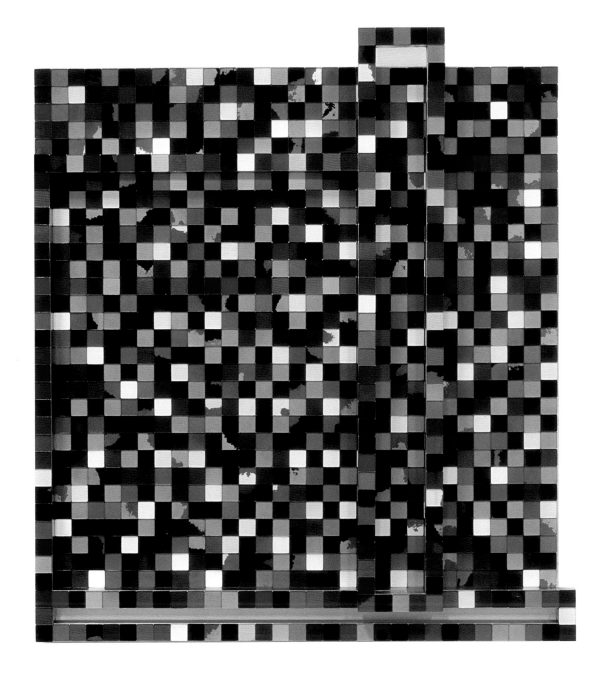

LA BOOGIE, 2005
EYESHADOW, PIGMENT, ALUMINUM
49 X 48 X 4 INCHES
PRIVATE COLLECTION

ICOSAEDER, 2005
COMPRESSION CAST COSMETIC PIGMENT, METAL ALLOY, METAL TIN PLATE
12 X 17 X 17 INCHES

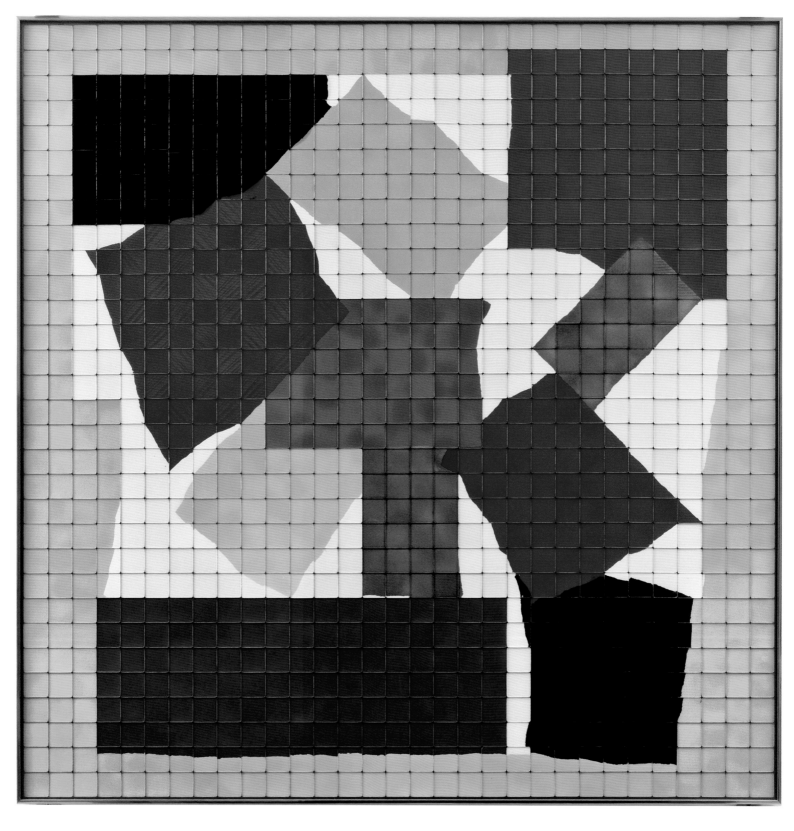

L'ESCARGOT, 2007
EYESHADOW, ALUMINUM
46 X 46 X 2 INCHES
COLLECTION OF DINA AND EITAN GONEN

L'ESCARGOT—COMPRESSION CUT, 2007
EYESHADOW, ALUMINUM
46 X 46 X 2 INCHES
PRIVATE COLLECTION, LOS ANGELES

VIOLET QUINACRIDONE (WARHOL), 2010
EYESHADOW, ALUMINUM
42 X 42 X 1 INCH
COLLECTION OF MARA AND RICKY SANDLER

PERIWINKLE (WARHOL), 2006
EYESHADOW, ALUMINUM
40⁷/₈ X 40⁷/₈ X 1 INCH
PRIVATE COLLECTION, LOS ANGELES

VIRIDIAN GREEN (WARHOL), 2008
EYESHADOW, ALUMINUM
42 X 42 X 1 INCH
PRIVATE COLLECTION

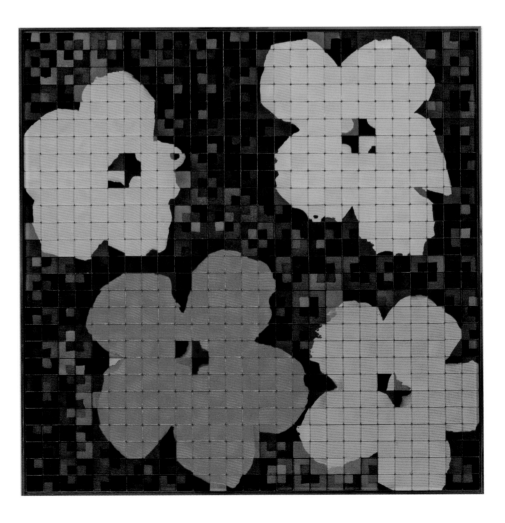

QUINACRIDONE ROSE (WARHOL), 2008
EYESHADOW, ALUMINUM
42 X 42 X 1 INCH
REGINA KULIK SCULLY, SAN FRANCISCO

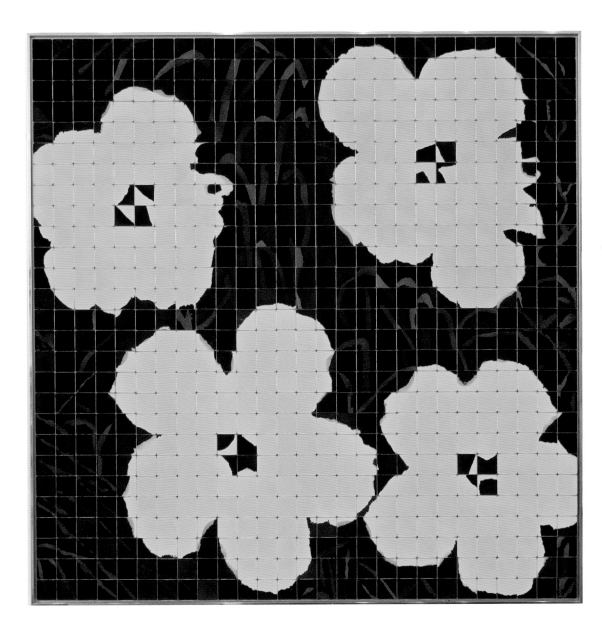

SAFFRON (WARHOL), 2008
EYESHADOW, ALUMINUM
42 X 42 X 1 INCH
REGINA KULIK SCULLY, SAN FRANCISCO

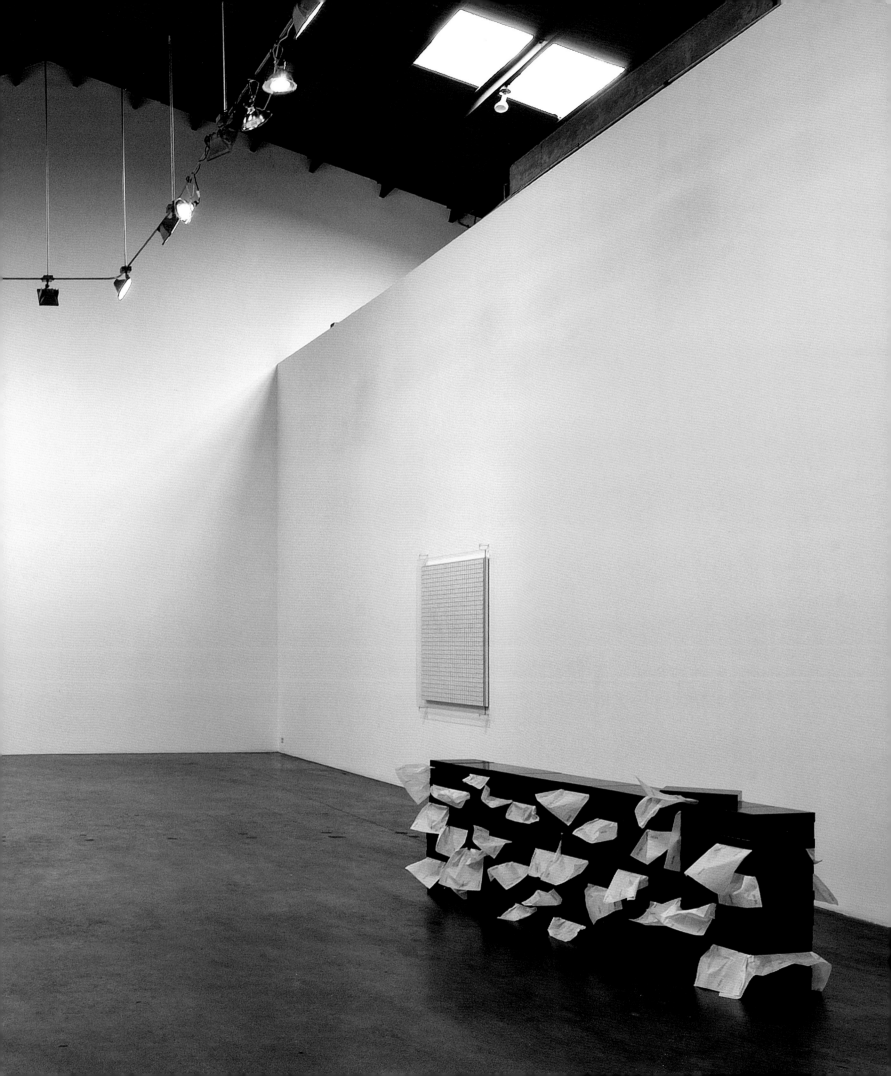

by JILLIAN HERNANDEZ

MAKEUP ON THE FACE OF THE FATHER: RECENT WORK BY RACHEL LACHOWICZ

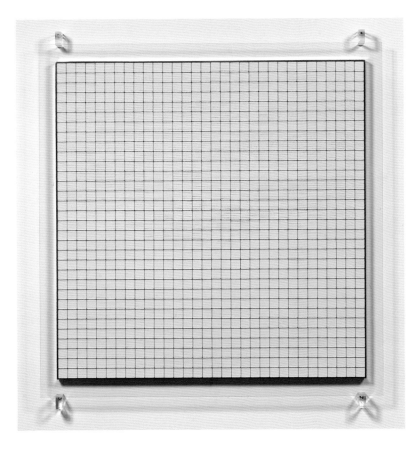

RACHEL LACHOWICZ is primarily recognized for appropriating canonical works by modern and contemporary male artists, such as Yves Klein and Carl Andre, and re-creating them using red lipstick. Since the 1980s, such appropriations have articulated a feminist position on the exclusion of women from art history and the continued inequities that women experience in the art world today.[2] In reviewing the critical literature on the artist, I have found that most authors focus on the appropriation strategies in Lachowicz's work. Yet, her practice raises questions that exceed the purview of appropriation, as her complex use of materials and rigorous techniques process push a wide range of established boundaries. Her art complicates neat divisions between abstraction and the body, appropriation and homage, the cosmetic and the artistic, commodities and crafts, subjectivity and objectification.

In this essay, I identify the critical practices, ideas, and methods Lachowicz has developed and argue that her minimalist aesthetic performs feminist work by making over the face of the "father"—the patriarchal, capitalist, and militarist father that art historian Anna C. Chave found cloaked in the work of minimalist artists such as Richard Serra. In "Minimalism and the Rhetoric of Power," Chave posited that the objects of minimalist art—in their aggressive occupation of space and their cold, dangerous, antagonistic position toward viewers—signified and reified dominant power structures. In discussing the negative reception of minimalist artworks by the general public, Chave notes:

> That very loathing could be construed as a sign of this art at work, however, for what disturbs viewers most about minimalist art may be what disturbs them about their own lives and times, as the face it projects is society's blankest, steeliest face; the impersonal face of technology, industry, and commerce; the unyielding face of the father: a face that is usually far more attractively masked (1990, 55).

Lachowicz conducts a subtle and forceful effacing of patriarchal power by soiling it with the red, sticky, slimy stuff of femininity. Her cosmetic work on patriarchal ideology does not mask it, or even make it more attractive, however, but rather playfully portrays how power structures can be unmade and "made over." This is true of the work she created for the exhibition *Rachel Lachowicz*, which was on view at the Shoshana Wayne Gallery from November 6 through December 24, 2010, and showcased the artist's most recent projects.

PARALLEL LINES, 2010
PRESSED EYESHADOW, ALUMINUM, GLASS
49 X 49 INCHES
COLLECTION OF EILEEN HARRIS NORTON,
SANTA MONICA, CA

1 As quoted in Chave 2010.

2 Jerry Saltz, "Where the Girls Aren't: Art and Apartheid, the prime real estate is still a men's club (September 19, 2006), The Village Voice, http://www.villagevoice.com/2006-09-19/art/where-the-girls-aren-t/, accessed April 2011.

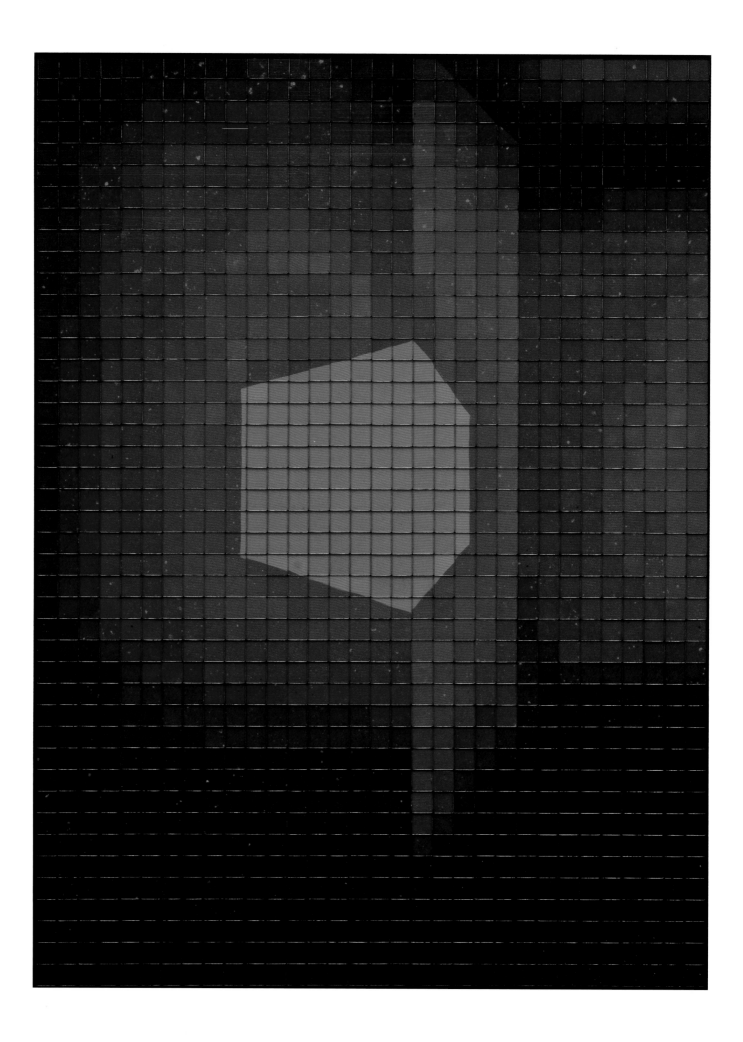

FADE TO BLACK THROUGH TWILIGHT (B36), 2010
PRESSED EYESHADOW, ALUMINUM, GLASS
67 X 50 INCHES
COLLECTION OF JEFFREY & MARLA MICHAELS

HERNANDEZ

Cosmetic Politics

All of us (men and women) compete through a lens of objectification. It runs through every aspect of our being. But for women an object relationship is part of our construct and remains a central factor of our sense of self. Our mind, body, work, grooming, and leisure all are related to the ways we are seen as a product or as a container. Previously, my work focused on reconfiguring known works and ideas in order to subvert or create new ones. I now am also looking at the housing, packaging, packing, and unpacking of ideas. ~ Rachel Lachowicz[3]

Lachowicz works against the grain of the once radical but now rote contemporary art practice of authorship denial and ironic appropriation. For how can an artist gendered "woman" deny an authorship that has for so long been denied to her in art history? And why should she reject the power afforded to her name if her legacy is not the enlightment regime of knowledge/power that the poststructuralists critiqued?[4] As Chave observes, "The erasure of artistic subjectivity that seemed such a radical prospect to certain male artists in the 1960s could hardly portend the same for their female contemporaries, for whom erasure was almost a given" (2000, 154). I find Lachowicz's homages and assertions of authorship some of the most inspired, inspiring, and critical aspects of her art. For it is important to recognize the artists, male and female, who have made your work possible and to ensure—especially if you are a woman—that your work is documented in history.

Claiming authorship is also a crucial strategy for Lachowicz because the cosmetic materials she employs are artistically undervalued, if not demonized, through their association with feminine consumption, fakery, deceit, low self-esteem, and hypersexualization, even by some feminists. Lachowicz's minimalist work, although deceptively void of volatile social content, takes enormous risks through its use of cosmetics, as not even the minimalist "rhetoric of power" she employs is strong enough to shift classist, sexist, and racist attitudes toward the uses and abuses of makeup. A dominant aesthetic tenet for women is to use makeup with enough skill so that it seems they are not wearing any. Women who exceed the parameters of taste with makeup are often mocked and derided (Hernandez 2009).

The feminized devaluations of makeup find parallels in the trope of prostitution that informs certain discourses on the value of art. In "Tricks of the Trade: Pop Art and the Rhetoric of Prostitution" visual-culture scholar Jennifer Doyle interrogates the mobilization of the rhetoric of prostitution in the critical reception of the work of Andy Warhol, which, like that of Lachowicz, openly cites signifiers of femininity. Warhol's work has been viewed as failing to articulate social critique, as colluding too closely with corporate and popular culture. Lachowicz's work risks similar devaluations because of its use of makeup. Doyle advances,

Insofar as it points out the absence of a solid apparatus for making distinctions between high art and mass culture or between the art object and the commodity, Warhol's work is a magnet for this rhetorical deployment of sex. When art critics mobilize this discourse to evaluate an artist's work, they map the anxieties of prostitution onto the vicissitudes of the category of art itself. The end product is a profoundly tautological rhetoric that backs up the assertion "I know art when I see it" with the accusation "I know a whore when I see one."

3 Artist statement for *Rachel Lachowicz* exhibition at Shoshana Wayne Gallery, 2010.

4 See Irigaray 1985.

110

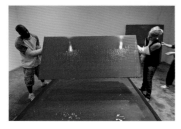

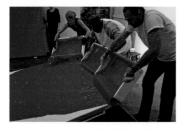

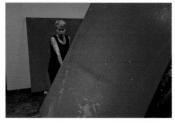

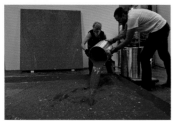

PRODUCTION IMAGES FROM
POUR: TRANSITIONAL STATES, 2010
DIGITAL PRINTS
12¾ X 18¾ INCHES EACH

So when Warhol the artist is outed as a fraud, it is by referencing a language of fraudulent, phony, imitation, or failed sex (2006, 48).

To varying degrees makeup and pop art are associated with fakeness, the hypersexual, social climbing, and lack of authenticity. Despite its established postmodern paradigm, the contemporary art world continues to valorize innovation and authenticity.

Narrow readings of Lachowicz's practice could frame her use of cosmetics and appropriation as a shtick. I am not interested in countering these real and imagined critiques of her work with arguments about how her practice "really" is unique and how makeup does not have to index the fake. What is critically significant about her practice and what its minimalist style enables is the open-ended opportunity for the viewer to reinterpret and revaluate "makeup" and "art" in all of their varied significations. Lachowicz's work, like Warhol's, poses aesthetic questions that make the cultural ground upon which high art rests glamorously unstable. If, as Doyle points out, "aesthetic value is derived from the transcendence of processes of objectification (Ibid. 59)" in the art historical canon, Lachowicz's emphasis on the rigorous aesthetic work of cosmetic grooming, and her assertions that these practices of objectification are not always exploitative or deny women's agency,[5] generates a new paradigm for thinking "art" through the quotidian realm of makeup, and vice versa.

Revealing and Concealing the Artist's Hand and Body

"In order to gain control of my practice I had to learn how to make everything." ~ Rachel Lachowicz

In our discussions, Lachowicz mentioned how sometimes viewers assume the cosmetics in her work are bought from a store and then assembled. Because the artist has become so adept at learning how to fabricate makeup in her studio, it is often mistaken for commercial products. In this sense, her works contain the secret of their making. Her painstaking process of generating the materials for her work is not evident on the surface. Although she has photographs documenting her painting process in *Pour: Transitional States* (2010), there are no images showing the artist making eyeshadow works. Lachowicz uses a press to produce eyeshadow powder from specialized pigments and bonding agents that are forged with twenty tons of pressure. The artist custom orders the powder's tins from cosmetic companies. When she started employing the medium, she would fill each container with only one color. As her practice has developed, she has learned various techniques to incorporate lines and gradations of color within each small container in order to generate patterns and shading that result in complex, large-scale compositions.

When citing Karl Marx, feminist literary theorist Emily Apter notes that, "In his discussion of commodity fetishism, Karl Marx spoke of an object's hidden value—its fetish character—as a 'secret': 'Value, therefore, does not stalk about with a label describing what it is. It is value, rather, that converts every product into a social hieroglyphic

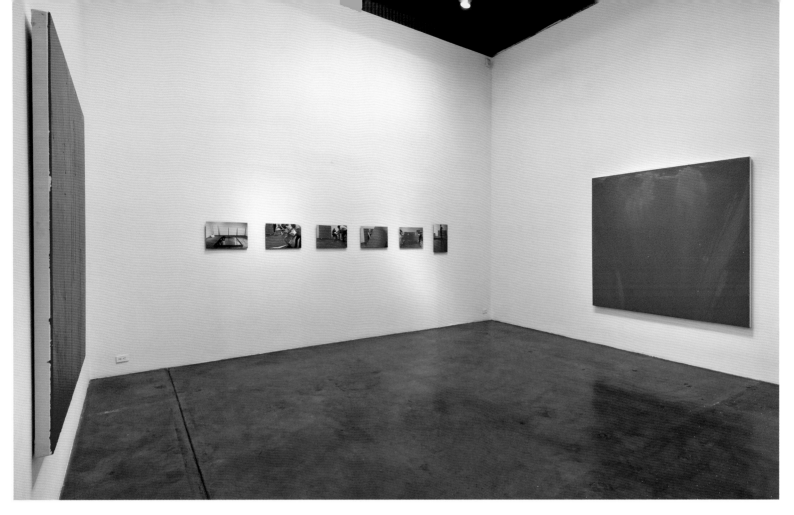

(Apter 1991, 1).'" Rachel Lachowicz's work resignifies the social hieroglyphics of makeup in ways that prompt view-ers to imagine its possibilities beyond the body. Her art troubles our relationship to eyeshadows and lipsticks, materi-als that we only come into contact with through the mediation of the market. In Lachowicz's hands, lipstick becomes sumptuous paint and eyeshadow pigment transforms into abstract line. In the Agnes Martin–inspired piece *Parallel Lines* (2010), white eyeshadow containers form a grid that is traversed horizontally by soft and virtually invisible thin black lines of eyeshadow. This work is one example among many of how Lachowicz renders the materials that make female bodies hypercorporeal, or hypermaterial, into abstract, minimal objects. The feminized stuff of compacts, mirrors, and purses comes to bear the vestiges and do the aesthetic work of high art.

The invisibility of Lachowicz's hand in most of her work keeps it from entering the realm of craft. At the same time, the specialized and time-consuming nature of her practice is not the standardized, mechanized labor that produces most makeup commodities. The artist states, "My interest is oppositional to showing labor; it is in captur-ing a kind of morphing, flickering slew of signifiers which coalesces to something sensuous and strong, profiling the unconscious space of femininity, which includes seeing ourselves in things factory made and corporate produced."[6] Lachowicz is interested in how objectification and commodification shape female subjectivity. We discussed how contemporary women construct their bodies to achieve entry and success in the business world through such practices as grooming, diet, exercise, and formalized dress. These practices stem from the limited modes of embodiment and personhood available to women, who need to market their bodies as commodities, or products.

The manner by which women strive to improve their social standing through bodily modifications is a topic cogently examined by literary theorist Lauren Berlant in her essay "National Brands, National Body." Berlant spe-cifically analyzes the novel and films *Imitation of Life* to explore the politics of female embodiment and citizenship in America. The novel (1933) and films (1934/1959) tell the story of a white widowed woman who works to support herself as a single mother along with a black female companion who is also a single mother. Berlant examines the

5 Unless otherwise noted, all quotations are from my conversation with Lachowicz in January 2011.

6 E-mail correspondence with author, April 2011.

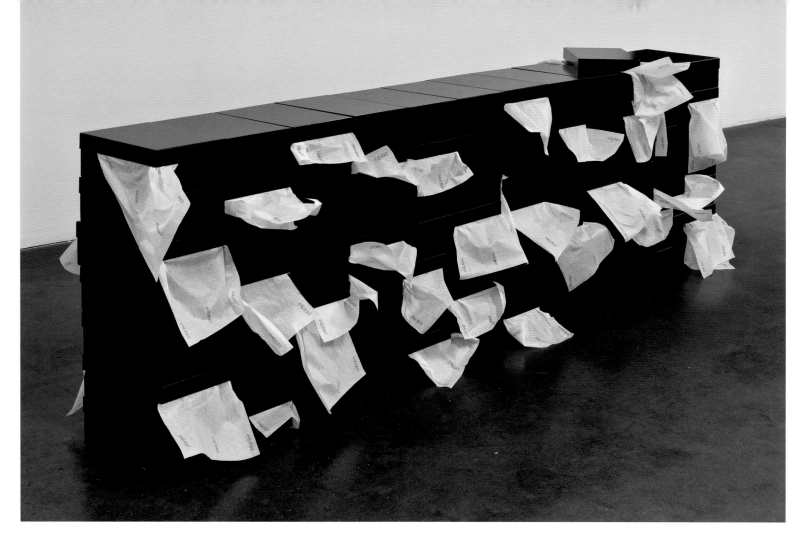

various ways these women negotiate their embodiment in order to gain access to the privileges of normative (white male) citizenship in the different iterations of the text. The women in these stories become trademarks and sexualized commodities in order to achieve social mobility—strategies that continue to provide the few avenues of publicity available for women. Berlant's position is worth quoting here at length, as it helps frame the critical work performed by Lachowicz's creation of cosmetic "commodities":

> I have argued that, by designating certain forms of legitimacy in abstract personhood and not the flesh, in American culture legitimacy derives from the privilege to suppress and protect the body; the fetishization of the abstract or artificial "person" is constitutional law and is also the means by which whiteness and maleness were established simultaneously as "nothing" and "everything." . . . One of the main ways a woman mimes the prophylaxis of citizenship is to do what we might call "code-crossing." This involves borrowing the corporal logic of an other, or a fantasy of that logic, and adopting it as a prosthesis. . . . This is how racial passing, religion, bourgeois style, capitalism, and sexual camp have served the woman; indeed, in *Imitation of Life* this ameliorative strategy has become the "trademark" of female existence across race and class and sexual preference. . . . We have seen that in the modern United States, the artificial legitimacy of the citizen has merged with the commodity form: its autonomy, its phantasmatic freedom from its own history, seem to invest it with the power to transmit its aura, its "body," to consumers (2008, 141).

Berlant shows how the valuation of abstraction has marked women as hypermaterial bodies vulnerable to multiple forms of oppression, prompting the development of survival strategies such as code-crossing.

UNTITLED (BOX UNDER CONSTRUCTION WITH LINER), 2010
POWDER COATED SHEET METAL, PAPER
84 ELEMENTS: 4 X 7⅝ X 11½ INCHES EACH
28¾ X 92 X 11½ INCHES

HERNANDEZ

By using the nonrepresentational visual codes of abstraction and minimalism—codes that are read as masculine—Lachowicz keeps her own body from becoming commodified in the art world. Her work diverges from embodied feminist art practices by employing the visual language of abstraction and minimalism to question constructs of femininity and the art historical valorization of masculine art. In fact, of the few bodies Lachowicz has featured in her practice the most visible are male. In the performance *Red Not Blue* of 1992, the bodies of muscular men parody the work of Yves Klein and Man Ray, who framed female bodies as passive objects. What Lachowicz performed was not an inversion of the phallocentric gaze, as she did not treat her assistants as lowly objects; rather, her male assistants were respected collaborators in the artistic process. Throughout the performance, she looked them in the eye and smiled warmly as she guided them through their actions, which included creating silhouettes by pressing their lipstick-smeared, nude bodies against white sheets of paper. In *Red Not Blue,* the legitimacy of the abstract personhood of the father is undone through marking him with makeup, making him a "body."

Feminism Under Construction: The Indeterminacy of Making and Consuming

Lachowicz dresses up art in the things that female gendered bodies are dressed in. Her use of materials that melt and smudge makes masculine, minimal art vulnerable. Conversely, she makes feminized commodity fetish objects—such as the shoeboxes in her piece *Untitled (Box Under Construction With Liner*, 2010)—sturdy, out of metal. Through these juxtapositions, Lachowicz blends pop art's mining of commodity culture, minimalist and abstract style, and feminist methods of resignification to make cosmetic practice and feminine consumption unfamiliar and strange and unknowable to us in visually alluring ways that are productive for rethinking gender, art, body, and power. If makeup can make art, can we view made up female bodies as similarly valued artifacts of culture?

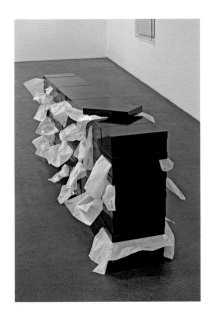

Untitled (Box Under Construction With Liner) is a large sculpture consisting of black rectangular forms that resemble sleek, high-fashion shoeboxes. The stable, grid-like composition is offset by the pieces of crumpled white lining paper that emerge from the boxes and resemble the scraps that scatter the floors of women's shoe stores. The signature of the artist is printed on the liner in a way that resembles a fashion designer's logo. The sculpture mimics shoeboxes so well that they seem light; in fact, they are made of heavy sheet metal. Here, Lachowicz employs sculpture and drawing to literally give "weight" to women's consumer practices and to the construction of their bodies, recognizing that these practices play a significant part in shaping contemporary social relations.

Following Berlant, the high-heeled shoes that one can imagine are contained in these boxes can be read as a prosthesis that enables women to successfully perform commodified femininity by changing their height and appearance. In recent years, the high-fashion woman's shoe, glorified in the television show *Sex in the City*, has come to represent postfeminist buying power as female liberation (Arthurs 2003). Instead of depleting her bank account to purchase Manolo Blahniks, however, the trademark "Rachel Lachowicz" is a product for consumption that provides a living for the artist, and asserts the value of her name—not of her body.

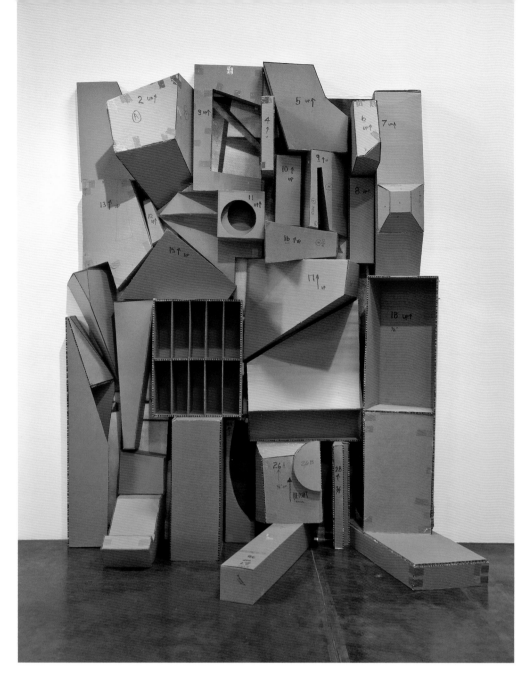

UNTITLED 3D SKETCH, 2010
CARDBOARD, PAPER
144 X 125 X 53 INCHES

Although Lachowicz and I discussed the pleasures and powers that can attend being a sexualized feminine object and of making up the body, what I want to underscore is the way that her production process and open-ended citations of feminized objects paves complicated paths for theorizing the nexus of gender, consumption, and body practices. How we buy and how we make our bodies consumable are complicated processes that cannot be adequately interpreted using mind/body, feminist/consumerist binaries, as these are multifaceted and indeterminate processes that Lachowicz's work uniquely provokes us to consider in their complexity.

Take, for example, the dynamics of interiority and exteriority that she explores in the large-scale works *Untitled 3D Sketch* (2010) and *Interlocking Construction* (2010). *Untitled 3D Sketch* is the model for *Interlocking Construction,* and both pieces were included in the *Rachel Lachowicz* exhibition at the Shoshana Wayne Gallery. Lachowicz produced the three-dimensional sketch by creating abstract shapes out of cardboard and placing them over the surface of a ten-foot paper reproduction of Kurt Schwitter's *Merzbau* that was affixed to her studio wall. The objects Lachowicz crafted were inspired by images of Schwitter's forms but did not replicate them.

Sharing space with this three-dimensional sketch is an intense physical experience. Your body wants to come near it to examine its contours, seams, and hollow spaces, and is simultaneously provoked to move back and appreciate its harmonies of line and shadow, and receding and advancing forms. The eyes move uncontrollably as they survey the work's multifaceted surface. The artist described the process of creating *Untitled 3D Sketch* as follows, "I am building with Kurt Schwitters thinking of Nevelson and Lee Bontecou." The compositionally poetic and commanding large-scale work reveals the measurements the artist used for fabricating the objects that comprise *Interlocking Construction.* The numbers and arrows inscribed on the cardboard pieces to aide in the creation of *Interlocking Construction* become oblique signs and aesthetic marks in the context of the gallery space, evidencing the precarious slippage between the aesthetic and the functional.

In *Interlocking Construction,* transparent, abstract Plexiglas shapes drawn from *Untitled 3D Sketch* are filled with varying shades of blue eyeshadow pigment. Here, the makeup gives "form" to the sculpture, functioning not as decoration

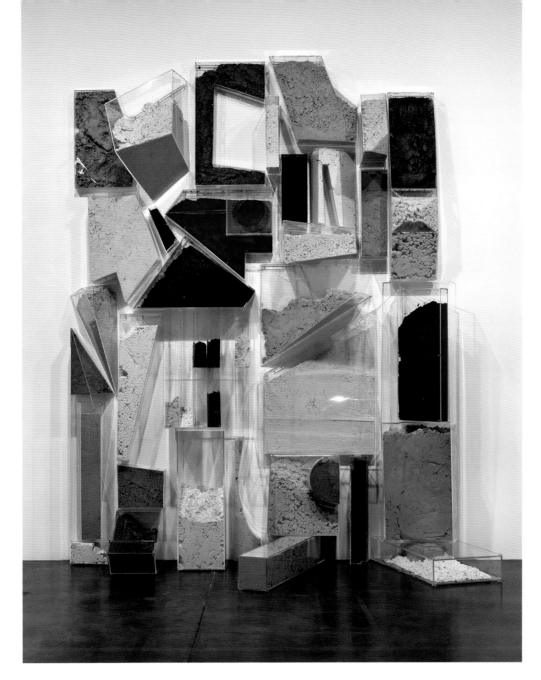

CELL: INTERLOCKING CONSTRUCTION,
2010
PIGMENT—COSMETIC COMPOUND,
PLEXIGLAS
144 X 125 X 53 INCHES

or adornment, but as the work's central interior element, its core. Lachowicz's approach challenges the higher value placed on interiority and "authenticity" over surface, as there is no clear demarcation in the pieces between sketch and finished artwork, and in *Interlocking Construction,* the "substance" of the interior consists only of makeup.

A Monument for "Mothers"

Lachowicz's method of drawing from the work of other artists in creating such pieces as *Untitled 3D Sketch* reveals the significant role homage plays in her practice. She distinguishes her mode of homage from the ironic stances of contemporary methods of appropriation. In our discussion, the artist playfully referred to the homages in her recent works as "drive-bys." In contrast to the connotations of violence and thievery that attend the term "drive-by," for Lachowicz this Los Angeles slang signifies proximity, not appropriation, theft, or replication. In describing her approach to referencing the work of such artists as Schwitters, Nevelson, and Bontecou, the artist asserted, "I want to come near things, but I want these things to mutate to become their own hybrid that recognizes its interlocking relationships." Lachowicz explores the poetics of intimate relationships in her homage to Mary Cassatt.

Female bodies are signified through pink bergamot soap in Lachowicz's sculpture *Untitled (Homage to Mary Cassatt,* 2010). The soap references Cassatt's feminine domestic scenes, such as *The Bath* (ca. 1892), which is the specific inspiration for Lachowicz's piece. In the painting, a woman holds her daughter on her lap as she washes her feet in a basin, both figures serenely focused on the intimate task. Cassatt seems like an unlikely influence for Lachowicz, who does not embrace a representational style, but Lachowicz's desire to honor Cassatt stems from her role as a pioneering artist who provided a feminine perspective on the world. In discussing this work, the artist stated,

I have always liked that painting. It is firmly planted in my mind. I think I saw it physically for the first time with my mother in that giant impressionist show which toured, possibly in the '70s. My mother is an artist and my art education started at a very young age. The communication between the figures is familiar. I have been single

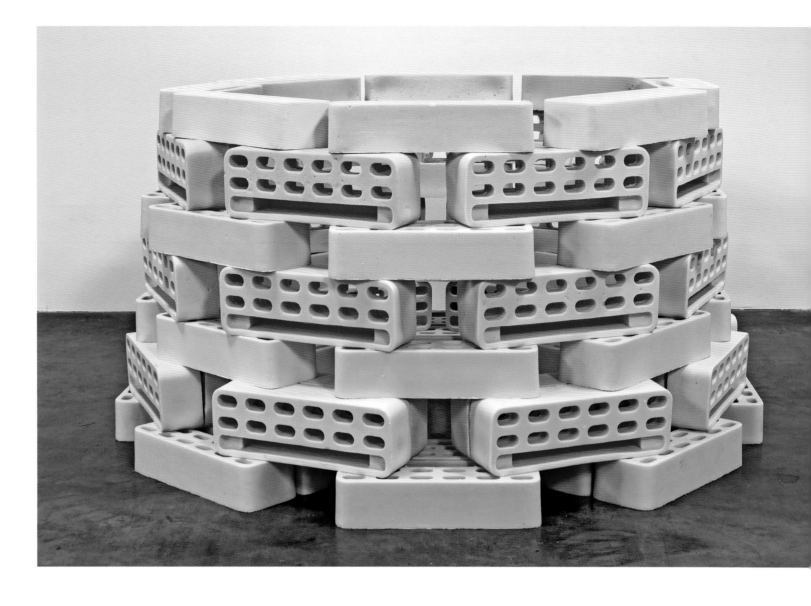

116

7 E-mail correspondence with author, April 2011.

8 E-mail correspondence with author, April 2011.

UNTITLED (HOMAGE TO
MARY CASSATT), 2010
SOAP, BERGAMOT ESSENCE
51½ X 97 INCHES (DIAMETER)

for most of my career. I now have a family and care for three children. Bath time is indescribably important, something Cassatt's painting shows, worthy of a monument. . . . I chose a circular structure for the work in an attempt to avoid a patriarchal gesture. It acts more like an installation than a sculptural object because it interacts with its surroundings in profound ways. Firstly, the obvious scent of the soap, scented soaps being an index of femininity. Secondly, upon entering the gallery the scent gives reference to the body without it being present. The work is an homage to a woman, but there is leeway for men to find it applicable. The scented soap is a way to talk about the act of bathing and habitual rituals of femininity, which have been almost invariably represented by voyeuristically presented female nudity.[7]

Discarded Styrofoam packaging from Apple computers were replicated in soap for Lachowicz's sculpture. In describing their production, the artist recalls,

I made giant molds of the packaging and each morning in our garage we cooked two thirty-plus-gallon batches of bergamot pink soap and poured them into the molds to be cast before going to the studio to work all day. It ended up being important to the homage that the whole family was involved in its manifestation. The kids, Walter, and I made all these soap blocks together. So ironically, I have become the insulation or the packaging between the kids and the boyfriend and the art object in this relationship.[8]

CORNER CONVERGENCE FIRING BLUE, PINK AND GREEN, 2010
PRESSED EYESHADOW, ALUMINUM, GLASS
29 X 62 INCHES

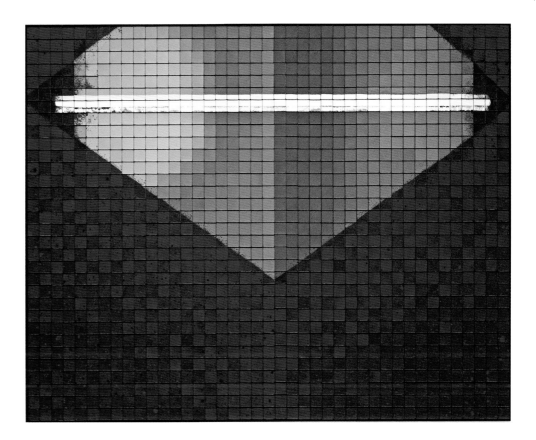

WORKS CITED

Applin, Jo. 2006. " 'This Threatening and Possibly Functioning Object': Lee Bontecou and the Sculptural Void." *Art History* 29 (3): 476-502.

Apter, Emily. 1991. *Feminizing the Fetish: Psychoanalysis and Narrative Obsession In Turn-of-the-Century France*. Ithaca and London: Cornell University Press.

Arthurs, Jane. 2003. "Sex and the City and Consumer Culture: Remediating Postfeminist Drama." *feminist Media Studies* 3 (1): 83-98.

Berlant, Lauren. 2008. *The Female Complaint: The Unfinished Business of Sentimentality in American Culture*. Durham and London: Duke University Press.

Chave, Anna C. 1990. "Minimalism and the Rhetoric of Power." *Arts Magazine*. January: 44-63.

———. 2000. "Minimalism and Biography." *The Art Bulletin* 82 (1): 149-163.

———. 2010. "Sculpture, Gender, and the Value of Labor." *American Art* 24 (1): 26-30.

Doyle, Jennifer. 2006. Sex Objects: Art and the Dialectics of Desire. Minneapolis and London: Univeristy of Minnesota Press.

Grosz, Elizabeth. 1994. *Volatile Bodies: Toward a Corporeal Feminism*. Bloomington, IN: Indiana University Press.

Hernandez, Jillian. 2009. "'Miss, You Look Like a Bratz Doll': On Chonga Girls and Sexual-Aesthetic Excess." National Women's Studies Association Journal 21 (3): 63-91.

Irigaray, Luce. 1985. *This Sex Which Is Not One*. Ithaca, NY: Cornell University Press.

Packaging here for Lachowicz indexes the product of her relationships, not the façade of a commodity. Like Cassatt, Lachowicz is not a biological mother, but mothers and female guidance play a critical part in her life—from the mother who taught her about art and feminism to the caregiving relationships she has established with her boyfriend's three young daughters. *Untitled (Homage to Mary Cassatt)* is a "sculpture to be sensed" (Applin citing Lippard 2006, 495). The nonrepresentational art object references the absent female body through scent, evoking the hypermaterial from the immaterial. The sculpture's welcoming appeal to our senses provides a feminist alternative to the detached cool of minimalist art that Chave critiqued. Rachel Lachowicz's work provokes us to view, smell, and feel our bodies (ourselves) as valuable packages encasing carefully crafted and beautifully volatile products (Grosz 1994). This work also facilitates our recognition of the artist mothers who for so long have been eclipsed by the face of the father.|

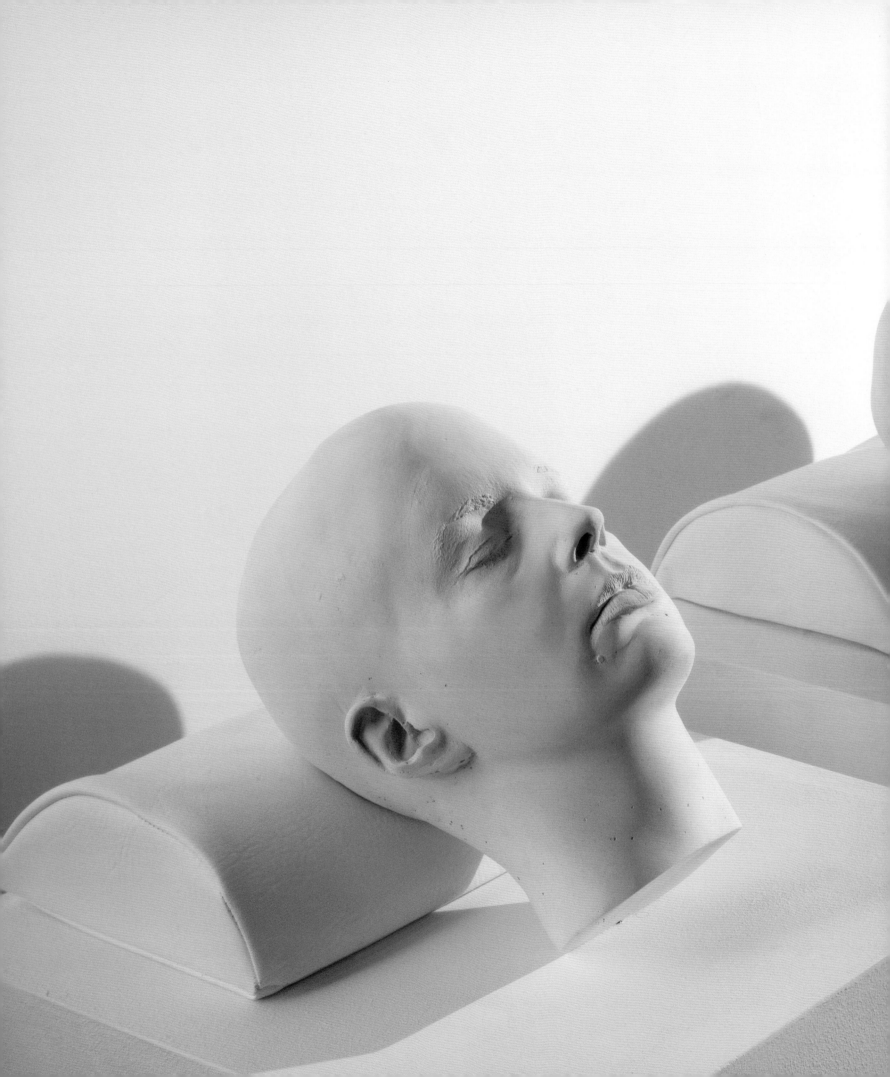

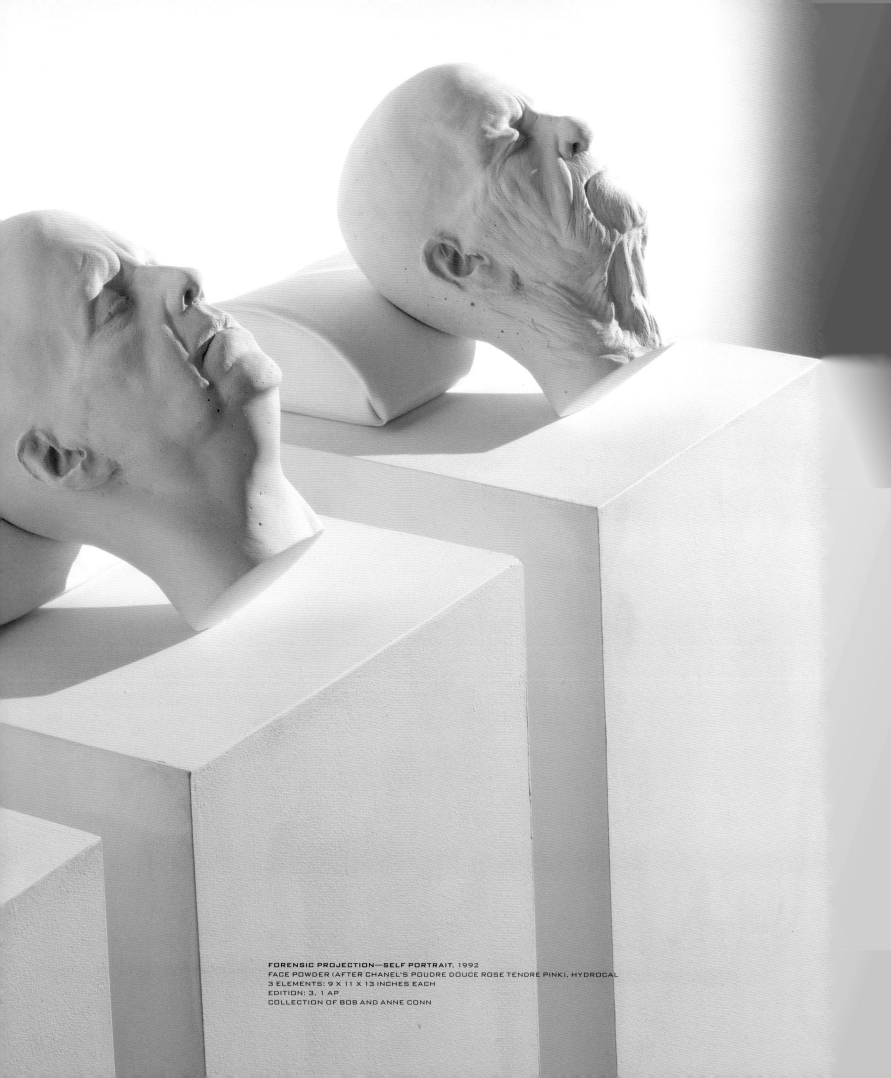

FORENSIC PROJECTION—SELF PORTRAIT, 1992
FACE POWDER (AFTER CHANEL'S POUDRE DOUCE ROSE TENDRE PINK), HYDROCAL
3 ELEMENTS: 9 X 11 X 13 INCHES EACH
EDITION: 3, 1 AP
COLLECTION OF BOB AND ANNE CONN

BIOGRAPHY AND BIBLIOGRAPHY

RACHEL LACHOWICZ

1964 Born in San Francisco
Lives and works in Los Angeles

EDUCATION

1988 BFA California Institute of the Arts, Valencia

AWARDS

2003 John Simon Guggenheim Memorial Fellowship
2001 The Edward C. Field Award
 Lightproject Art Foundation
1995 Louis Comfort Tiffany Foundation Award
1991 Art Matters
1988 Skowhegan School of Painting and Sculpture Fellowship, ME

PUBLIC COLLECTIONS

Albright-Knox Art Gallery, Buffalo
The Bronx Museum of the Arts
The Denver Art Museum
Israel Museum, Jerusalem
Los Angeles County Museum of Art
Museum of Fine Arts, Boston
Museum of Contemporary Art, Los Angeles
Museum Moderner Kunst Stiftung Ludwig Wien, Vienna
Orange County Museum of Art, Newport Beach, CA
Palm Springs Art Museum, CA
Whitney Museum of American Art, New York

SOLO EXHIBITIONS

2010 Shoshana Wayne Gallery, Santa Monica, CA

2008 Shoshana Wayne Gallery, Santa Monica, CA

2005 Patricia Sweetow Gallery, San Francisco
 Shoshana Wayne Gallery, Santa Monica, CA

2001 *Chrysalis*, lightproject, Los Angeles
 Cryo-Field, lightproject, Los Angeles

2000 Kapinos Galerie für Zeitgenössische Kunst, Berlin

1999 Peggy Phelps Gallery, Claremont Graduate University, CA

1998 Cristinerose Gallery, New York

1997 Dogenhaus Galerie, Berlin

1996 Shoshana Wayne Gallery, Santa Monica, CA

1995 Magazin 4, Vorarlberger Kunstverein, Bregenz, Austria
 Fawbush Gallery, New York

1993 Shoshana Wayne Gallery, Santa Monica, CA
 Rhona Hoffman Gallery, Chicago

1992 Newport Harbor Art Museum, Newport Beach, CA
 Fawbush Gallery, New York

1991 Shoshana Wayne Gallery, Santa Monica, CA
 Dennis Anderson Gallery, Antwerp, Belgium

1990 Krygier/Landau Contemporary Art, Santa Monica, CA

1989 Krygier/Landau Contemporary Art, Santa Monica, CA
 Dennis Anderson Gallery, Los Angeles

GROUP EXHIBITIONS

2010 *Pink Miami*, Cerritos College, Norwalk, CA
 Think Pink—Gavlak, West Palm Beach, FL

2009 *Focus: The Figure*, Denver Art Museum (lecture series)

2008 *Summer 2008*, Shoshana Wayne Gallery, Santa Monica, CA
 Infrastructures, Wignall Museum at Chaffey College, CA
 Project for a New American Century, Rose Art Museum,
 Brandeis University, Waltham, MA
 Making It Happen, Bronx Museum of the Arts
 Highlights of the Permanent Collection, Bronx Museum of the Arts

2007 *Dangerous Beauty*, Palazzo Delle Arti Napoli, Naples
 Art Since the 1960s: California Experiments, Orange County Museum
 of Art, Newport Beach, CA
 Soft Core, Kim Light Gallery, Los Angeles
 Group Show, Shoshana Wayne Gallery, Santa Monica, CA
 Five Stories Higher, Track 16 Gallery, Santa Monica, CA

2006 *Matter of Fact*, Manhattan Beach Art Center, CA
 Reverence: awe.admiration.love.devotion.honor.respect., Hudson Valley
 Center for Contemporary Art, Peekskill, NY
 Flowers in Contemporary Art, Benaki Museum, Athens, Greece
 Raw Materials, Riverside Art Museum, Riverside, CA
 100 Artists See God, Cheekwood Museum of Art, Nashville

2005 *100 Artists See God*, traveled to: Institution of Contemporary Arts,
 London; Contemporary Art Center of Virginia,
 Virginia Beach; Albright College Freedman Art
 Gallery, Reading, PA

2004 *100 Artists See God*, traveled to: The Contemporary Jewish
 Museum, San Francisco; Laguna Art Museum, CA
 Santa Monica Originals, Arena 1, Santa Monica Airport, CA

2003 *Influence, Anxiety, and Gratitude*, The Mit List Visual Arts Center,
 Cambridge, MA, curated by Bill Arning
 100 Artists See God, curated by John Baldessari and Meg Cranston,
 Naples Art Museum, FL, traveling (catalogue)

2002 *Dangerous Beauty*, The Jewish Community Center, New York
 Profiler., Canterbury Royal Museum and Art Gallery,
 Kent, England
 Retrospectacle: 25 Years of Collecting Modern and Contemporary Art,
 Denver Art Museum
 100 Artists See God, curated by John Baldessari and Meg Cranston
 for the Independent Curators Incorporated, traveling (catalogue)
 Art after Art, Neues Museum, Weserburg Bremen, Germany
 (catalogue)
 Structure, Patricia Sweetow Gallery, San Francisco
 That Place, The Moore Space, Miami

2001 *Song Poem*, curated by Steven Hull, Cohan Leslie and Browne,
 New York
 Locating Drawing, organized by Maureen Mahony and Doug Lawing,
 Lawing Gallery, Houston
 Enduring Love, Klemens Gasser & Tanja Grunert, Inc., New York

2000 *Made in California 1900–2000*, Los Angeles County Museum of Art
 Shades of Grey, Boulder Museum of Contemporary Art, CO
 Box Project, Museum of Installation, London, traveling to:
 Angel Row Gallery, Nottingham, England, and Turnpike Gallery,
 Greater Manchester, England

1999 *Post-War, Pre-Millenium: Works from the Collection of the Denver Art Museum*,
 University of Colorado, Boulder Art Gallery
 Ideas in Things, curated by Tim Jahns, Irvine Fine Arts Center, CA
 54 X 54 X 54: 54 snapshots, 54 artists, 54 pounds a photo, organized by
 Michael Petry, Museum of Contemporary Art, London (catalogue)
 The Time of Our Lives, The New Museum, New York
 Sans Titre: Works from the Collection of Peggy, David and Scott Teplitzky,
 Boulder Museum of Contemporary Art, CO

1998 *Cleveland Collects Contemporary Art*, curated by Tom E. Hinson,
 Cleveland Museum of Art
 Inner Eye: Contemporary Art from the Marc and Livia Straus Collection,
 Samuel P. Harn Museum of Art, University of Florida,
 Gainesville
 Double Trouble: The Patchett Collection, Museum of Contemporary
 Art, San Diego (traveling)

1997 *Simple Form*, curated by Sheryl Conkelton, Henry Art Gallery,
 University of Washington, Seattle
 LAX, Dogenhaus Galerie, Leipzig, Germany
 Fracturing the Gaze, Lawing Gallery, Houston
 Boxes for Musée Imaginaire, Museum of Installation, London
 Filler, Shoshana Wayne Gallery, Santa Monica, CA
 Critiques of Pure Abstraction, curated by Mark Rosenthal for the
 Independent Curators Incorporated, traveling to Krannert Art
 Museum, University of Illinois, Champaign
 Champaign, Frederick R. Weisman Museum, University of
 Minnesota, Minneapolis

1996 *Just Past: The Contemporary in the Permanent Collection, 1975–96*,
 Museum of Contemporary Art, Los Angeles
 Some Grids, Los Angeles County Museum of Art
 Praticas Transgressivas: Women in Red, Galeria Luis Serpa, Lisbon
 B.F.K.L.T., Silverstein Gallery, New York
 The Paranoid Machine, curated by Michael Cohen, Shoshana Wayne
 Gallery, Santa Monica, CA
 Critiques of Pure Abstraction, curated by Mark Rosenthal for the
 Independent Curators Incorporated, traveling to UCLA/Armand
 Hammer Museum of Art and Cultural Center, Los Angeles;
 Crocker Art Museum, Sacramento, CA; Madison Art Center, WI;
 The Lowe Art Museum, Coral Gables, FL

1995 *Images of Masculinity*, Victoria Miro Gallery, London
 Duchamp's Leg, curated by Elizabeth Armstrong, Center for the
 Fine Arts, Miami
 Passions Privees, Musee d'Art Moderne de la Ville de Paris (catalogue)
 Inside Out, Aldrich Museum of Contemporary Art,
 Ridgefield, CT (catalogue)
 Critiques of Pure Abstraction, curated by Mark Rosenthal for the
 Independent Curators Incorporated, traveling to Sarah Blaffer
 Campbell Gallery, University of Houston; Illingworth Kerr
 Gallery of the Alberta College of Art & Design, Calgary, Canada;
 Sheldon Memorial Art Gallery, University of Nebraska, Lincoln
 (catalogue)
 Action/Performance and the Photograph, curated by Craig Krull,
 traveling to Allen Memorial Museum, Oberlin College, OH;
 Hatton Gallery, Colorado State University, Fort Collins;
 Presentation House Gallery, Vancouver, BC; Mount St. Vincent
 University and St. Mary's University, Halifax, Nova Scotia,
 Canada; Reese Bullen Gallery, Humbolt State University, Arcata,
 CA; Forum for Contemporary Art, St. Louis; Edwin A. Ulrich
 Museum of Art, Wichita State University, KS; Mishkin Gallery,
 Baruch College, New York (catalogue)

1994 *Duchamp's Leg*, curated by Elizabeth Armstrong, Walker Art Center,
 Minneapolis
 Identity, the Logic of Appearance, curated by Shoshana Blank,
 Galerie Krinzinger, Vienna
 Sense and Sensibility: Women and Minimalism in the Nineties,
 curated by Lynn Zelevansky, Museum of Modern Art,
 New York (catalogue)
 Working Around Warhol, Pittsburgh Center for the Arts
 The Art of Seduction, curated by Bonnie Clearwater,
 The Center Gallery at Miami Dade Community College
 (catalogue)

1993 *Fourth Newport Biennial Southern California 1993*, curated by
 Bruce Guenther, Newport Harbor Art Museum,
 Newport Beach, CA (catalogue)
 Action/Performance and the Photograph, Turner/Krull Gallery,
 Los Angeles
 Fall from Fashion, curated by Barry A. Rosenberg, Aldrich Museum,
 Ridgefield, CT
 Disorderly Conduct, P.P.O.W. New York, NY in cooperation
 with Nina Felshin

Venice Biennale "Aperto 93," curated by Christian Leigh and
 Pedro Almodovar, Venice
Fontannelle—Incidents of Art, curated by Christoph Tannert and
 Micha Kapinos, Potsdam, Germany (catalogue)
bODD, Basel Art Fair, Switzerland
Body Parts, Haines Gallery, San Francisco
Naming of the Colors, curated by Bill Arning, White Columns,
 New York (catalogue)
Fear the Future, curated by Dianne Vanderlip, Denver Art Museum
I Am the Enunciator, curated by Christian Leigh, Thread Waxing
 Space, New York (catalogue)

1992 *Fever*, curated by Jeanett Ingberman and Papo Colo,
 Exit Art/The First World, New York
 The Anti-Masculine (Overlapping but not corresponding to the feminine),
 curated by Bill Arning, Kim Light Gallery, Los Angeles
 Abstraction for the Information Age, curated by Irit Krygier,
 The Works Gallery, Costa Mesa, CA
 Getting to Know You: Sexual Insurrection and Resistance, organized by
 Christoph Tannert and Dean McNeil, Kunstlerhaus Bethanien,
 Berlin (catalogue)
 The Auto-Erotic Object, curated by Julie Carson, Hunter College,
 New York (catalogue)
 Installations and Constructions, Tavelli Williams Gallery, Aspen, CO
 In Pursuit of a Devoted Repulsion, Roy Boyd Gallery, Santa Monica, CA
 Summer 1992, Shoshana Wayne Gallery, Santa Monica, CA
 The Fiar International, Milan, Rome, Paris, London, New York,
 Los Angeles
 Ornament: Ho Hum All Ye Faithful, John Post Lee Gallery, New York

1991 *Facing the Finish: Some Recent California Art*, San Francisco Museum
 of Modern Art; Santa Barbara Contemporary
 Arts Forum, CA; Art Center, Pasadena, CA
 Plastic Fantastic Lover, Blum Helman Warehouse, New York
 The Lick of the Eye, curated by David Pagel, Shoshana Wayne
 Gallery, Santa Monica, CA
 Group Show, Dennis Anderson Gallery, Antwerp, Belgium
 Five Days, Thomas Solomon's Garage, Los Angeles

1990 *Aperto*, Galleria Notturna d'Arte Contemporanea, Milan
 Membership Has Its Privileges, a collaboration with Gary Simmons,
 Lang & O'Hara Gallery, New York
 Spirit of Our Time, Contemporary Arts Forum, Santa Barbara, CA

1989 *Modern Objects*, Richard/Bennett Gallery, Los Angeles
 Sculpture from New York and Los Angeles, Krygier/Landau
 Contemporary Art, Santa Monica, CA

1988 *2nd PACIFIC A-MORE CHRISTMAS EXHIBITION*, curated by
 Thomas Solomon, Los Angeles

Artner, Alan G. "Post Feminist Feminism." *Chicago Tribune,* February 12, 1993.

Avgikos, Jan. "Sense and Sensibility, Museum of Modern Art." *Artforum,* October 1994, 98–99.

Baker, Kenneth. "The End Is the Thing at Modern." *San Francisco Chronicle,* September 21, 1991, C5.

Berry, Colin. "Conceptual Color: In lbers' Afterimage' at SFSU." *Artweek,* November 2001.

Bonami, Francesco. "Plastic Fantastic Lover." *Flash Art,* January/February 1992, 125.

Bonetti, David. "Artists Find Fresh Ways of Looking at the Human Torso." *San Francisco Examiner,* May 28, 1993, E11.

———. "Modernism Goes International." *San Francisco Examiner,* September 20, 1991.

Cameron, Dan. "Critical Edge." *Art & Auction,* December 1992, 48, 50.

Chadwick, Susan. "3 Exhibits on Abstract Painting Worth a Visit." *The Houston Post,* February 2, 1995, D8.

———. "Abstracts on Abstraction." *The Houston Post,* January 27, 1995, G8.

Clearwater, Bonnie. *The Art of Seduction* (catalogue). Miami, FL: Miami-Dade Community College, 1994.

Clewing, Ulrich. *Zitty,* November 2, 1993, 195.

Clowes, Judy. "Art vs Art." *Isthmus,* June 7, 1996, 22.

Collins, Judith. *Sculpture Today.* London: Phaidon Press, 2007.

Crockett, Tobey. "Reviews of Exhibitions." Santa Monica Edition, *Art in America,* January 1992, 123.

Crowder, Joan. "And in the End." *Santa Barbara News—Press,* July 19, 1991, 7.

———. "Catching the Spirit of Our Time." *Artweek,* December 1991, 20.

Curtis, Cathy. "Essence Proves to Be Only Skin Deep." *Los Angeles Times,* November 24, 1992, F6–7.

———. "Los Angeles, NY Art Scenes: More Than Just Miles Apart." *Los Angeles Times,* October 25, 1993, F10.

———. "Of Makeup and Motion." Orange County Edition, *Los Angeles Times,* October 9, 1992, F26.

———. "Painting Pictures." Orange County Live, *Los Angeles Times,* October 14, 1993, 3, 4, 9, 16.

Cussi, Paola. "Rachel Lachowicz: Shoshana Wayne Gallery, Santa Monica." *Modern Painters,* June 2005.

Donato, Debora Duez. "Rachel Lachowicz." *New Art Examiner,* April 1993.

Doove, Edith. "Feminisme in Lippenstift" [Feminism in lipstick]. *Het Nieuwsblad* (Antwerp, Belgium), May 29, 1991.

Dubin, Zan. "Liberating Her Body of Artwork." Orange County Edition, *The Los Angeles Times,* October 7, 1992, F1.

Ellegood, Anne. "Old Dogs, New Tricks," in *The Time of Our Lives* (catalogue). New York: New Museum of Contemporary Art, 1999.

Farr, Sheila. "The Hit List." *Seattle Weekly,* December 3, 1997.

Feinstein, Dan. "Enter EXIT Again." Style Calendar, *New York News Day,* December 20, 1992.

Mademoiselle. "Fine Art." May 1993, 94.

Fiore, Kristin. "Professional Criticism: The Armand Hammer's 'Critiques of Abstraction.'. . ." *Daily Bruin,* February 5, 1996, 21–25.

Fontanelle (catalogue). Potsdam, Germany: Kunstpeicher, 1993: 234.

Frank, Peter. "Art Pick of the Week, Critiques of Pure Abstraction." *LA Weekly,* March 8–14, 1996, 126.

———. "Art Picks of the Week, Erica Rothenberg, Rachel Lachowicz." *LA Weekly,* April 8–14, 2005.

———. "Pick of the Week." *LA Weekly,* September 29–October 5, 1989.

———. "To Be Young, Gifted and Los Angeleno." *Visions,* 1989.

———. "Yoko Ono, Rachel Lachowicz, Art Picks of the Week." *LA Weekly,* April 26–May 2, 1996, 134.

Frederikson, Eric. "Simple Not Plain." *Stanger,* November 27, 1997.

Geer, Suvan. "Rachel Lachowicz." *Art Scene,* October 1992, 13.

———. "Remodeled Desire, Rachel Lachowicz and Margaret Honda at Shoshana Wayne Gallery." *Artweek,* December 2, 1993, 16.

———. *Los Angeles Times,* September 15, 1989.

Glueck, Grace. "Hesse's Robust Paintings at Miller Upend Expectations." *The New York Observer,* November 2, 1992, 23.

Grabner, Michelle. "Reviews: Wisconsin, 'Critiques of Pure Abstraction.'" *New Art Examiner,* November 1996, 38.

Guenther, Bruce. *Fourth Newport Biennial Southern California.* Newport Beach, California: Newport Harbor Museum, 1993.

Hackett, Regina. "Minimalism Takes New Forms in Henry Exhibit." *Seattle Post-Intelligencer,* November 18, 1997.

Hammer, Klaus. "Ikonen der Alltaglichkeit." *Neue Zeit,* January 14, 1993.

Hammond, Pamela. "Sculpture Krygier/Landau." *ARTnews,* 1989, 178.

Harvey, Doug. "Hurd So Good." *LA Weekly,* July 28–August 3, 2006.

Hayden, Niki. "'First' Exhibit Shows off Newest Works." *Boulder Daily Camera,* 1993.

Heartney, Eleanor. "Sense and Sensibility." *art press,* October 1994, 2–3.

Hess, Elizabeth. "Give Me Fever." *Village Voice,* December 29, 1992, 95.

———. "Minimal Women, 'Sense & Sensibility: Women Artists & Minimalism in the Nineties.'" *Village Voice,* July 5, 1994, 91–92.

Hughes, Robert. "A Flawed Ex-Paradise." *Time Magazine,* December 11, 2000.

James, Eric. "Blaffer Gallery Goes Abstract with Latest Exhibit." *The Daily Cougar,* February 1, 1995.

Johnson, Patricia. "Pushing Past Purity: Exhibition Traces Continuity of Abstract Painting through '90s Attempts to Reshape It." *Houston Chronicle,* January 30, 1995, 12, 16.

Kalin, Tom. "'Plastic Fantastic Lover' (Object A)." *Artforum,* January 1992, 102.

Kandel, Susan, "L.A. in Review," *Arts Magazine,* November 1991, 97.

———. "30 Artists Take Aim at Masculinity." *Los Angeles Times,* December 17, 1992, F10–11.

———. "Feminine Critique." *Los Angeles Times,* April 19, 1996, F25, F28.

Kapitanoff, Nancy. "Stomping on Unwanted Images of Women." *Los Angeles Times,* October 14, 1991, 92.

Kimmelman, Michael. "Promising Start at a New Location." Review/Art, *The New York Times,* December 18, 1992.

Knight, Christopher. "'Bad Girls': Feminism on Wry." *Los Angeles Times,* February 8, 1994, F1.

———. "Curatorial Concept in Search of an Enemy." *Los Angeles Times,* February 11, 1996, 57–58.

———. Art Review, *The Los Angeles Times,* May 1, 1992, F24.

Kocaurek, Lisa, "Plastic Fantastic Lover," *Ms. Magazine,* January/February 1991, 69.

Kreis, Elfi. "Parforceritt durch die Design-Geschichte: Die Dogenhaus Projekte zeigen Arbeiten der Amerikanerin Rachel Lachowicz." *Seite 28/Der Tagesspiegel Sonnabend,* November 22, 1997.

Lavin, Maud. "What's So Bad About 'Bad Girl' Art?" *Ms. Magazine,* March/April 1994, 80.

Levin, Kim. "Voice Choices." *The Village Voice,* March 10, 1992, 73.

———. *The Village Voice,* July 27, 1993.

Littlefield, Kinney. "Facing the Gender Gap." *The Orange County Register,* October 9, 1992, 75.

———. "Oh Boy, Artist Skewers Stereotypes." *The Orange County Register,* November 4, 1992, B3.

Mahoney, Robert. "Plastic Fantastic Lover." *Arts Magazine,* January 1992, 81.

Marino, Melanie. "Rachel Lachowicz at Fawbush." *Art in America,* June 1995, 105.

McKenna, Kristine. "California Dreaming." *Los Angeles Magazine,* November 2000.

Melrod, George. "Lip Shtick." *Vogue,* June 1993, 88–90.

Mifflin, Margot. "Feminism's New Face." *ARTnews,* November 1992, 120–25.

Muchnic, Suzanne. "In These United States of California." Calendar, *Los Angeles Times,* September 17, 2000.

The Naming of the Colors (catalogue). New York: White Columns, 1993.

Pener, Degen. "Egos & Ids." Styles of the Times, *The New York Times,* December 13, 1992.

Pincus, Robert L. "The California Condition." *The San Diego Union-Tribune,* November 26, 2000.

Porges, Maria. "Openings: Rachel Lachowicz." *Artforum,* January 1993, 80.

———. "Rachel Lachowicz: Patricia Sweetow Gallery." *Artforum,* February 2006, 217.

Potter, Chris. "Site." *Pittsburgh Newsweekly,* July 7–13, 1994, 34.

Preuss, Sebastian. "Zwischen Schlafzimmer und Afrika." *Berliner Zeitung,* November 8–9, 1997.

Relyea, Lane. "Charles Ray; In the No." *Artforum,* September 1992, 63.

Roman, Shari. "In Your Face Art—Art Attack In L.A." *In Fashion,* March 1993, 96.

Rosen, Steven, "First Sightings," *Denver Post,* April 4, 1993.

Rosset, Yves. "Die Kunst der Beschwörung." *die Tageszeltung (Berlin),* May 9, 2000.

Rugoff, Ralph. "Beep Beep Toot Toot: The Trouble with 'Bad Girls,'" *LA Weekly,* February 18, 1994, 43.

———. "Missing Persons." *LA Weekly,* August 2, 1991.

Ruiters, Mark. "Antwerpen Galeries: Lachowicz—Burkhart." *Kunst und kultur* (Brussels), June 1991.

Sacharow, Anya. "'Fever,' Fashion and Foreign Affairs." *ARTnews,* February 1993.

Sajbel, Maureen. "Makeup Artist." *Los Angeles Times Magazine,* November 22, 1992, 58.

Scarborough, James. "Guys & Dolls, The Anti-Masculine at Kim Light Gallery." *Artweek,* February 4, 1993, 23.

———. "Lipshtick: A Conversation with Rachel Lachowicz." *Artweek,* October 24, 1992, 16.

———. "One Thing or Another." *Artweek,* September 23, 1993, 18.

———. "Rachel Lachowicz—Newport Harbor Art Museum." *Flash Art,* March 1993, 86.

Schiche, Ericka. "Abstract Divorce." *Public News,* February 22, 1995, 12.

Selwyn, Marc. "Reviews: Los Angeles," *Flash Art,* March/April 1992, 116.

Shaw, Brittain. "Blaffer Exhibit Puts Abstraction in Modern Light." *Houston Chronicle,* January 28, 1995, 1, 4.

Silver, Lisa. "They've Got The 'Fever.'" *Paper Magazine,* February 1993.

Smith, Roberta. "A Raucous Caucus of Feminists Being Bad." *The New York Times,* January 21, 1994, B1.

———. "Body of Evidence." *Vogue,* August, 1994, 152, 154, 158.

———. "Group Shows In SoHo for a Weekend of Gallery Hopping." *The New York Times,* January 15, 1993, C30.

———. "Scant Space for Show by Women." *The New York Times,* June 24, 1994, B6.

———. "Women Artists Engage the Enemy." *The New York Times,* August 16, 1992, 1; also appears in *International Herald Tribune* (Paris), August 23, 1992.

Snow, Shauna. "Rachel Lachowicz's New Role: 'Just Looking at Life.'" Styles of the Times, *Los Angeles Times,* December 16, 1991, 109.

Tannert, von Christophe. "Das Schöne muß verderben." *Berliner Zeitung,* December 5, 1997.

Thiel, Wolf-Günter. "Rachel Lachowicz: Dogenhaus Projekte." *Flash Art,* January/February 1998, 119–20.

Ticket Berlin. "Anspruchsvoller Feuerteufel: Rachel Lachowicz züdelt am Image." November 27–December 3, 1997.

Turner, Elisa. "Seducing Viewers with Questions of Art." *The Miami Herald,* January 30, 1994, 101.

———. "The Art of Seduction." *ARTnews,* Summer 1994, 184.

Updike, Robin. "Minimalist Sculpture in a Spacious Room: Poles, Lights and Lipstick Fill Henry." *Seattle Times,* November 14, 1997.

Van Proyden, Mark. "Born to Shop." *Artweek,* October 24, 1992, 1; Interview with James Scarborough, 16.

Van Proyen, Mark. "Rachel Lachowicz at Patricia Sweetow Gallery." *Artweek,* December/January 2006, 11–12.

Varnedoe, Kirk. *Pictures of Nothing: Abstract Art Since Pollock.* New Jersey: Princeton University Press, 2003.

The Village Voice. "Voice Choices." October 30, 1991.

Vincent, Steve. "Exit Art's Clintonian Return." *Art & Auction,* February 1993.

Vogel, Carol. "The Art Market." *The New York Times,* December 4, 1992.

Wallach, Amei. "Reinventing Art for the '90s." *New York News Day,* December 11, 1992.

Weinraub, Bernard. "Beyond Tans and Tinsel." *The New York Times,* October 23, 2000.

Welchman, John. "Para Metrology: From the White Cube to the Rainbow Net." *Art + Text* 53, 1996, 58–65.

Werneburg, Brigitte. "Ornament und Bananenröckchen." *die Tageszeitung Sonnabend/Sonntag,* November 8–9, 1997.

Wilson, Jane. "Lipstick, Ashes: The Art of Feminism." *The Aspen Times,* July 11/12, 1992, 4B.

Wilson, William. "Biennial Uses Humorous Paradox to Tackle Issues." *Los Angeles Times,* October 9, 1993, F13.

———. "Local Traditions Alive in FIAR Exhibit." *Los Angeles Times,* February 6, 1993, F12.

———. "Thoughts Go Public at Newport Harbor." *Orange County Art Review,* October 6, 1993, F1, F6.

Wolgamott, L. Kent. "Purely Abstract." *Lincoln Journal Star,* November 26, 1995, 13H.

Woodard, Josef. "Review Shorts: 'Spirit of Our Time.'" *Artweek, 1991,* 18.

Zellen, Jody. "Rachel Lachowicz." *Arts,* March 1991, 85.

CONTRIBUTORS

GEORGE MELROD has written regularly about contemporary art and culture for more than twenty years, for magazines such as *Art in America*, *ARTnews*, *World Art*, *American Ceramics*, *VOGUE*, *Mirabella*, *Details*, *Los Angeles*, and various other publications. In the 1990s, he was the New York critic for *Sculpture* magazine and wrote a monthly contemporary art column for *Art & Antiques*, for whom he worked as a contributing editor. He moved from New York to Los Angeles in 1998. Since 2007, he has been the founding editor of *art ltd*.

AMELIA JONES is Professor and Grierson Chair in Visual Culture at McGill University in Montreal. Her recent publications include major essays on Marina Abramović in *The Drama Review*, feminist art and curating, and performance art histories, as well as the edited volume *Feminism and Visual Culture Reader* (2003; new edition 2010). Her book *Self Image: Technology, Representation, and the Contemporary Subject* (2006) was followed in 2012 by *Seeing Differently: A History and Theory of Identification and the Visual Arts* and her major volume, *Perform Repeat Record: Live Art in History*, coedited with Adrian Heathfield.

JILLIAN HERNANDEZ is a PhD candidate in the Women's and Gender Studies Department at Rutgers University and an independent curator. She is currently conducting dissertation research on girls' embodiment and sexuality in Miami, where she directs the Women on the Rise! art outreach program for teenage girls at the Museum of Contemporary Art. Her work has been published in peer-reviewed and edited publications, and she has presented research at conferences organized by the College Art Association, Cultural Studies Association, and National Women's Studies Association, among others.

Published by Marquand Books, Seattle

www.marquand.com

in collaboration with Shoshana Wayne Gallery,

Santa Monica, CA.

"Rachel Lachowicz: The Make-Up Artist" © 2012, George Melrod.

"Not: Rachel Lachowicz's Red Not Blue, 1992" © 2012, Amelia Jones.

"Makeup On the Face of the father: Recent Work by Rachel Lachowicz" © 2012, Jillian Hernandez.

Unless otherwise noted, all images copyright © 2012, Rachel Lachowicz.

Book design by Laura Gruenther

Color managment by iocolor, Seattle

Printed and bound in China by C&C Offset Printing Co.

Photography by

Gene Ogami : pages 2–4, 6, 15, 22, 96–97, 102–09, 111–12, 114–21, 129–131

William Nettles : pages 8, 10–11, 32, 35, 38, 52, 59, 64

Christopher Bliss : pages 51, 66

Tom Warren : pages 76, 78

David Brandt : pages 80–81

Richard Nicol : page 54

Oren Slor : page 69

Available through DAP / Distributed Art Publishers

155 Sixth Avenue, 2nd floor, New York, NY 10013

Tel: (212) 627-1999 / Fax: (212) 627-9498

Library of Congress Cataloging-in-Publication Data

Rachel Lachowicz/essays by George Melrod, Amelia Jones, Jillian Hernandez.

pages cm

Includes bibliographical references.

ISBN 978-0-9882275-2-1 (alk. paper)

1. Lachowicz, Rachel, 1964-—Criticism and interpretation. I. Melrod, George.
Rachel Lachowicz. II. Lachowicz, Rachel, 1964- Works. Selections.

N6537.L325R33 2013

709.2—dc23 2012039075

COVER:
RED NOT BLUE, 1992
PERFORMANCE AT SHOSHANA WAYNE GALLERY,
SANTA MONICA, CA

ENDSHEETS:
FADE TO BLACK THROUGH TWILIGHT (B36),
2010
PRESSED EYESHADOW, ALUMINUM, GLASS
67 X 50 INCHES
70½ X 52 INCHES (GLASS)
COLLECTION OF JEFFREY & MARLA MICHAELS

TITLE PAGE:
PRODUCTION IMAGE FROM
POUR: TRANSITIONAL STATES, 2010
DIGITAL PRINT
18¾ X 12¾ INCHES

DETAILS FROM PAGES 52–53:
(LEFT)
ONE MONTH LATE, 1992
DENVER ART MUSEUM COLLECTION:
FUNDS PROVIDED BY RICHARD S. BERGMAN,
JILL KATZ BERNSTEIN, PETER COGGAN,
ALLAN A. CAPPS, PATSY AND ARNOLD PALMER
FOUNDATION, THOMAS C. PATCHETT,
LINDA RUBIN AND DON SANDEL AND
SHOSHANA WAYNE GALLERY, 1992.548
(C) DENVER ART MUSEUM
(RIGHT)
UNTITLED (LIPSTICK URINALS), 1992
DENVER ART MUSEUM COLLECTION:
GIFT FROM VICKI AND KENT LOGAN, 2001.772
(C) DENVER ART MUSEUM